SCRAPE OFF THE BLACK

D0185325

Tunde Ikoli

SCRAPE OFF THE BLACK

OBERON BOOKS
LONDON

Published in this edition in 1998 by Oberon Books Ltd.
(incorporating Absolute Classics)
521 Caledonian Road, London N7 9RH
Tel: 0171 607 3637 / Fax: 0171 607 3629

First published by Methuen Books in 1995

British Library Cataloguing-in-Publication Data
A catalogue record for this book is available from the British Library.

ISBN 1 84002 084 9

Front cover photograph: Robert Day

Cover design: Andrzej Klimowski

Typography: Richard Doust

Printed in Great Britain by Antony Rowe Ltd., Reading.

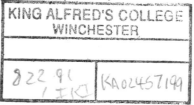

Front cover photograph: actors Chrissie Cotterill (foreground) and Ade Ikoli.

CONTENTS

A THEATRE DIRECTOR'S
JOURNEY TO THE OBVIOUS

L et me state clearly at the outset this essay is not attempting
to give a history of Black theatre in Britain. I am not
knowledgeable enough to pay adequate tribute to that struggle's
pioneers, many of whom I now count proudly among my
friends.

Out of deep respect for them I have to stress that all I am
attempting is to tell the story of one White-administered
theatre's journey in the 1980s and 90s in the company of a
troupe of several hundred Black and Asian artists who have
contributed their bountiful talents to the Theatre Royal,
Stratford East.

The journey was part of a much longer one for me
personally. I was brought up as a racist. I do not mean that my
parents taught me to be so. However, being born before the
Second World War in suburban Manchester I was brought up
at a time when the attitude to Black people was commonly
what we would now recognise as racist.

I never saw any Black people, apart from the occasional
American soldier. Black people featured as golliwogs on jam
jars, as stupid or evil natives in Tarzan films on Saturday
mornings or as happy, eye-rolling servants in films set in the
Deep South. If I asked where mummy was, a jocular aunt might
say "she's run off with a black man." I'd be taught nursery
rhymes about catching a nigger by the toe. I can remember
my teacher at primary school showing us how small Britain
was on the globe and how much of the world we owned, a
world to which apparently we'd brought civilisation and many
benefits of which we should be very proud. No hint of what we
owed to other cultures or to slavery or even to Black servicemen
defending our country at that time.

Being in Australia for secondary school and university in
the fifties only confirmed my ignorant prejudices. The
Aborigines were held to be a feckless lot who, unfortunately,

were resident in Australia before the White Australia Policy was adopted to protect a White, preferably Anglo-Saxon, majority.

I won't go through all the shaming incidents which were part of my slow re-education on my return to England in 1960. Indeed I can't, because I've repressed most of them, but I'm fairly sure I can remember a stage of being surprised when I saw a Black talking head on television making an intelligent contribution to a debate. The knowledge I once had such a thought gives me a hot flush of shame even as I write.

I was well past that stage when I became artistic director of the Theatre Royal Stratford East, in the East End of London, in 1979, but nevertheless still had a lot to learn, and I've now learnt enough to know that I always will have.

The simple philosophy of Stratford East is that theatre should form a continuous loop with its community. It should draw ideas, concerns and talents from its community and concoct shows which connect back to that community.

From this basic idea all else follows. It becomes essential to make the theatre accessible to all sections of the community, through the subject matter of the shows, the kind of artists performing in them, the style of the publicity and marketing, the prices, the kind of welcome the theatre gives and through the education and training policies.

The Theatre Royal is in Newham which is usually named in any survey as one of the three most deprived boroughs in the country, with more than half its residents eligible for some form of state benefit. So, low prices become an essential, and I'm proud that now over half our audience come in for £2, and, if they are eligible for that concessionary price, they can book the best seats available at the time of booking. This guarantees an audience mixed in age, race and class in all parts of the theatre, instead of poorer audience members being confined to the gallery.

The other significant fact about Newham, which was to make my job particularly invigorating, is that it is the first borough in Britain where Whites are only the largest minority.

The choice of play is of course, vital in determining the composition of the audience attracted to a theatre. The very first play I chose for Stratford East in 1979 was Mustapha Matura's *Welcome Home Jacko*, which was set in a Black youth club, and the second, although it had a White writer, Barrie Keeffe, centred on racial issues.

However, this was not the start of a conscious revolution. Indeed no further plays by a Black writer appeared on our stage until over three years later, and that was a revival of *Welcome Home Jacko*, re-staged because many of the young cast had now become much-loved characters in a T.V. comedy series, *No Problem*. For the first time young Black people had their own British stars. I knew this meant the play would now reach a wider audience, and of course also be financially successful. I don't think at the time this particular theatre director was so committed to the development of Black theatre as to have any Black plays under commission.

Just prior to that revival though there was at least one conscious attempt to widen the range of roles on offer to Black actors when I cast Joanne Campbell as the hero in *Jack and the Beanstalk*. Usually at that time Black actors were confined in pantomime to playing exotics like the Genie or the Good Fairy. Joanne may well have been the first Black actress to play the hero. She has since become a valuable member of the theatre's board, and our pantomimes now always have a Black or Asian hero or heroine, and sometimes both. One of the many actors who made their first appearance on stage in our pantomimes was David Harewood. Stratford East's silly-ass courtier was later to be the Royal National Theatre's first Black *Othello*.

Despite the breakthroughs in the fantasy world of pantomime, I'm ashamed to observe that we lost many opportunities for what is called colour-blind casting. We staged both *Hamlet* and large-scale musical adventure stories with all-White casts. We even staged plays about young Londoners and one about the Merchant Navy with a cast of twenty and managed to have no Black actors in them. That

wasn't even realistic for British life at the time, let alone progressive for our theatre policy.

Such narrowness of mind was the result of a middle-aged director like myself, and all the White guest directors we employed at the time casting principally from actors they know, and from their minds running along "conventional", meaning White, lines.

Welcome Home Jacko packed the Theatre Royal with vociferous, hugely enthusiastic mainly Black young people in 1983 and woke this particular theatre director up to the hunger among Black people to see their lives, and incidentally their T.V. heroes, on stage.

In 1984 we staged two very popular new Black plays, significantly both with Black directors, another step in me learning the obvious. Both plays were set in Jamaica and the Black directors brought a knowledge to them which British White directors, of course, would not have.

A serious turning-point in my commitment to Black theatre came two years later under the tutelage of Errol John, author of *Moon on a Rainbow Shawl*. I remember my first meeting with Errol in my flat. He was a handsome, intense, sharply intelligent man with a burning ambition, which was to direct a production of his play. It had won second prize in The Observer Play Competition in 1958, and had been directed by a highly-regarded White, West End director. Errol was so angered by this unreal and sentimental production that he'd sworn he wouldn't allow another production in Britain until he could direct it himself.

I much admired the play, which now has the status of a classic. However, I wondered if Errol's intense desire to "get it right" would make him too obsessive a director of it. Many authors who direct their own plays are inclined to be too exactly demanding of actors, giving them intonations from the first day of rehearsal, and not allowing them to find their version of a role, resulting in "dead" performances. However the obvious breadth of Errol's humanity overcame my doubts and I committed at that first interview to him directing this large-cast play at our theatre with no idea of

how I'd raise the money for it at the time. This was too important a risk not to take.

In fact his play was part of a three-play season of Black plays, which, indeed, included another play directed by the author. This was one of Trevor Rhone's marvellous Jamaican comedies, *Smile Orange*. We staged four of Trevor's plays throughout in the eighties, two directed by him and the others by two of the very few experienced British Black directors at that time, Anton Phillips and Yvonne Brewster.

We staged the three Black plays consecutively bridging 1985 and 1986 in a conscious attempt to make a serious breakthrough with Black audiences. Up to that time all but one of our Black plays had been comedies. Two of the plays in our Black Season were dramas, and we had a special grant from the Greater London Council to help with the marketing to new audiences.

This was one of hundreds of enlightened acts by the G.L.C. to aid the development of Black and Asian work. However, it was the last of them. Mrs. Thatcher, infuriated by the G.L.C.'s popular policies, closed them down and our cheque was one of the last to be got out of the building. The season was very successful and the reality of *Moon on a Rainbow Shawl* was much helped by Equity allowing us to import two experienced older actors, Errol Jones and Barbara Assoon, from Trinidad.

There were barely a dozen experienced good older Black actors in Britain at that time and half of them, Norman Beaton, Mona Hammond, Carmen Munroe, Rudolph Walker, Alastair Bain and Corinne Skinner-Carter appeared on our stage in the eighties. However, there were a large number of up-and-coming Black actors, graduating mainly from youth theatres, rather than from the more traditional route of full-time drama schools. That season saw the first of many recruits to the acting profession who came through our own youth theatre. I remember Yvonne Brewster's delight when she auditioned Roger Griffiths for *Smile Orange*. As soon as she saw him there was no further contest. Like many of our graduates he's gone

onto wider fame, in particular in his case to being Lenny Henry's assistant cook in the T.V. series *Chef.*

Another graduate of our youth theatre, Jo Martin, got her Equity card playing the maid in *El Dorado*, one of the two new plays we staged by the distinguished Black author, Michael Abbensetts. I presume it's become obvious by now that the majority of our shows are, in fact, premieres. Very few theatres can make that claim. It means, of course, that we can commission plays which will be of particular interest to all sections of the many communities that make up the East End of London.

We do very occasional revivals. One of these, the classic melodrama *The Ticket-of-Leave Man* by Tom Taylor, was responsible for a significant breakthrough in my still compartmentalised mind regarding colour-blind casting.

The previous show to this Victorian classic happened to be Henry Livings' version of the life of Josephine Baker, called *This Is My Dream.* I commissioned it because I saw a brief clip of Josephine Baker fooling around at a rehearsal and I realised how ideal Joanne Campbell would be for the role. In fact she gave one of the most brilliant performances I've ever seen, and I firmly believe, had the minds of most White critics not been as compartmentalised as my own, she'd have been up for awards.

When casting this show I thought I'd book five Black and five White actors to double the many Black and White characters who featured in Josephine's story. In her early background in the U.S. the characters were mainly Black. When she achieved stardom in Paris, and then remained in France the people in her life were mainly White. This created an imbalance in the way I could deploy the cast members. The designer and I were toying with very unsatisfactory ideas of how we could indicate when an actor was meant to be White or Black. Masks and black or white hats or gloves were mentioned.

After the first day of auditions I realised how ridiculous I was being. The talent of the actors indicated to me the best

way to proceed was to cast all Black actors, apart from the single role of a White racist commentator on the action. Accent, circumstances and sometimes deportment would tell the audience when a character was Black. Thus be it Martin Luther King or a French count, both would be played by Black actors, and so, to my delight, was Maurice Chevalier.

Despite this breakthrough in the compartments of my mind I didn't bring this knowledge to bear on the casting of the next show immediately. I was having difficulty casting the famous role of Hawkshaw, the detective in *The Ticket-of-Leave Man*. He was the first detective in British stage history, and while I was watching a performance of *This Is My Dream* I identified the right bravura for the role in the Black actor Ben Thomas who was, at that moment, playing a White, Southern, hell-fire preacher. It took me another three seconds to realise my own blindness. Why hadn't I thought of him as the detective? I'd managed to cast a Black actor in the comedy role of a young boy, a part normally played by an actress in Victorian times, to give it a comic edge. Yes, I'd cast a Black actor in a comic "exotic" role, but I hadn't contemplated one for the traditional detective part. I cast him, of course. He played it splendidly, and went on to play Algernon in *The Importance of Being Earnest* and the title role in *King Lear* for Yvonne Brewster's Talawa company.

However, I've jumped over a notable play staged in 1987 which was also significant in this history of our theatre's progress towards the obvious in the staging of Black work.

Scrape Off the Black proved a milestone in audience development. I saw an earlier version of it in a production by the now unfortunately extinct Black company Temba and was very taken with its humour and the obvious honesty of the experiences of the characters, an honesty and joy in detail which could only have been drawn from life.

Its author, Tunde Ikoli, had already written a large-scale youth theatre play for the Theatre Royal, and it soon became clear that *Scrape Off the Black* was indeed his own life-story,

with him as the elder son, Trevor. The radiant truth of the play and Tunde's excellent ear for the rhythms of East End dialogue, attracted four splendid actors all of whom knew well or lived in the East End.

The two actresses, both well-known on television, felt in the version we had that there was something missing in Act Two, notably in the part of the mother. I remember Jill Gascoine, Kate Williams, Tunde and I sitting around Jill's kitchen table in Whitechapel with the discussion centring on the fact that the mother's justification for putting her sons into a home was not expressed. Tunde was responsive to suggestions made, and I like to think that the mother's final defence was partly inspired by a story I told of a similarly crucial decision in my own mother's life. But I may be wrong. I've seen many people very certain of what they contributed to a play when I know that not to be the case.

There's no doubt though what the play contributed to the development of Stratford East. As director I loved watching the delight the audience took in it. The audience, like the play, was half Black and half White, with a notably high percentage of mixed couples attracted, no doubt, by the well-known cast because the men also, Gary McDonald and Chris Tummings, were T.V. faces.

Plays do not exist totally on the page, or indeed even on the stage. True they will not come to life at all unless there is a lively and creative give-and-take established nightly between the actors, but where the play actually exists is somewhere between the audience and the stage. It is my firm belief that the more mixed the audience is in age, race, class and experience the more resonances, and therefore the more meaning, a play has. This sets up a give-and-take too among the audience members.

My delight was to listen to the play, like a radio play, while I watched the audience. They'd start laughing early but gently as they tuned into the sniping banter of mother and son. No-one had trouble identifying with that. Race was unmentioned till the lines:

ROSE: You're not black.

TREVOR: I'm not white...

ROSE: You're half-caste.

This would get a trumpet of laughter from certain sections of the audience. You'd see White liberals glancing from the corner of their eyes at who was daring to find a remark about race funny. When they realised it was Black people laughing you could almost feel them adjusting to how to take this play and they'd join in laughing, tentatively at first at the dizzy Mary's obvious unconscious racism, and then with more confidence when they settled for the fact that it was the truth of the characters and of their dialogue that was important, as with any good play, and they could relax their antennae for political correctness even when in the company of Black people.

It was in 1987 too, immediately after *Scrape Off the Black*, that we staged our first Asian play, a version of the Indian classic *The Lost Ring*, a version too mongrel for outraged experts of Indian theatre. It was directed by the theatre's Associate Director, Jeff Teare, who went on to champion Asian work at our theatre.

In the same year Jeff directed our first new Asian play *The Fighting Kite*, about Asian youths becoming militant in response to White racism in Southall. This provoked a clear example of how White, often middle-class reviewers can be out-of-touch with the realities of street life.

One of them complained that such themes had been dealt with before in theatre and the play told him nothing new. On that same first night a young local Black actor brought a young Asian friend for his first visit to any theatre. The Asian man could not believe that the issues of his life had been staged accurately and he couldn't stop quoting lines in great excitement that he felt he could have written himself.

When the two of them left to go home they were attacked in the street by four White youths. They went to the nearest police station to report the attack and to their astonishment

found the youths had already been arrested. Apparently, they'd damaged some property early in the evening. The police were uninterested in charging the youths with the physical attack, despite the Asian's heartfelt cry "Look, that's my blood on his coat." White property was more important than Asian blood.

The relevance of the play to the lives of the two theatregoers could not have been more cruelly made, in contrast to the metropolitan critic's apparent view that plays should be written for the benefit of people whose job it is to see every new play.

Interesting, too, that while none of the great performances by Black and Asian artists I've seen over many years have appeared in critic's Best Actor lists, the performance by Rudolph Walker in Barrie Keeffe's *King of England* at the Theatre Royal won the Time Out Audience Award in 1988. Barrie is one of those rare White writers as yet brave enough and sensitive enough to write major roles for Black actors which he often did in the eight premieres of his we've staged.

By 1990 half the shows being staged at Stratford East were Black or Asian, almost exactly equating with the balance of White and Black and Asian people in the community.

The year began with one of only two Black American plays we'd ever staged. I'd been tempted at times to produce one of the many very good Black American plays I'd read but nearly always the primary demand to choose new Black British plays, for one of the only theatres in Britain with a large stage that would risk them, took precedence. An exception was Aaron Iverson's *Side Pockets.*

Resident in Chicago where I met him, Aaron had been writing for seven years with no-one staging any of his plays. This we did, which gave him kudos back home. Steppenwolf have since staged his work.

The other exception was a remarkable show staged by an American company, Free Street Theatre. Called *Project,* it was a show evolved by professionals with extraordinarily talented amateurs living in one of the most violent, drug-ridden, desolate, high-rise communities in the U.S.A., Cabrini Green in Chicago.

This was a vision of the hell our own tower block communities could contemplate arriving at further down the road, if the buildings weren't knocked down first.

It was another case of honour in another country, not available in your own. The show had been playing one-night stands on and off for two years in and around Chicago, unreviewed by the *Chicago Tribune*. However, the fact that it was appearing at a Theatre Royal in London as part of the London International Festival of Theatre provoked the *Tribune* to send a critic to London to review it. Unfortunately, that same, new-found prestige did not extend to the American Embassy in London who treated the cast in appalling racist fashion, embarrassing them greatly in front of the guests they'd invited from Stratford East.

The end of 1990 brought a show which was to affect radically the progress of Black and Asian drama at Stratford East, indeed of the theatre's whole future.

I'd seen a try-out of a musical late night at the National Theatre. Only an hour long it was already called *Five Guys Named Moe*. Its potential as a show to entertain local audiences at Stratford East was obvious and I made an immediate offer backstage after the show to the author, and leading member of the cast, Clarke Peters, even though I was convinced one of the many commercial producers I'd seen in the audience would be offering vastly more financially than I could.

Nine months later after two or three politely received but non-productive exploratory phone calls, I made a definite offer for the show to be staged at Stratford East without the necessity of seeing a draft of the second act which had not yet been written. I was relying on Clarke's manifest talent, and the adrenaline rush a definite opening date gives, for him to complete the full-length show. This was the risk commercial producers could not take.

Rehearsals went ahead. The predominance of American talent in the artistic producing team led to more sackings and walk-outs than we'd ever known at Stratford East. Americans

don't seem to think rehearsals are serious unless there's blood on the rehearsal room floor, as Peter Brook reported in *The Empty Space*.

Based on the music of Louis Jordan, with brilliant choreography by Charles Augins, and invaluable work on the basic motivation that prompted the songs by the soon-to-resign British Black director and with the contributions of a high-octane cast, the show was an instant success.

Cameron Mackintosh arrived with an office party for a jolly night out with no intention of buying the show, but, in fact, made an offer for it in the interval. His extraordinary producing expertise catapulted the show into being a big West End hit, and his even more extraordinary generosity in the deal he did with the theatre which took the original risk set the Theatre Royal up for five years of profits which meant we could continue our risk-taking investment in new shows.

The nineties saw an amalgam of trends in our Black and Asian work, which made up never less that half our programming and twice reached the level of seven out of nine shows in one year being by non-White authors. We twice hosted Black companies from South Africa, and one from the Royal National Theatre Studio, which was about the Caribbean contribution to the Second World War about which I was once so ignorant.

For the first time we staged plays by Black women, two by the more experienced Trish Cooke and one by our own local discovery, Debbie Plentie.

We staged large-scale co-productions with nearly all the leading, subsidised Black and Asian companies, including Black Theatre Co-operative, Talawa, Tamasha, Moti Roti and Tara Arts. Co-productions are of particular significance. If a Black company has reasonable subsidy it can come to a theatre with its own choice of play and sufficient economic power to negotiate a deal. The combined resources of the theatre and the company mean both can stage a larger show than usual. The Theatre Royal would provide the support staff but the Black Company was always in artistic control.

This process contains the obvious principle that I believe funding bodies should follow more often with Black companies. Trust their talent, give full support, take the risk, give them the money and let them be in charge of their own choices. It's a tremendous asset for Stratford East to work with such companies, but it's the major disgrace of British theatre that the number of Black and Asian companies is decreasing, and no producing theatre building is run by Black or Asian people.

A new development, led by Jeff Teare, was a conscious concentration on encouraging authors to write plays with characters of several races in them. Following on from Barrie Keeffe's successes in this field Paul Sirett wrote three plays, directed by Jeff Teare, of which *Worlds Apart* with a mixed race cast in an airport immigration lounge was a typical and also very successful example.

Three Asian directors, with their own companies, broke ground in very different areas for the Theatre Royal's stage. Jatinder Verma staged a very effective version of the classic Indian story *Heer Ranja*, Kristine Landon-Smith staged an adaptation of a novel set in a Bombay high-rise with obvious resonance for Newham residents and Keith Khan staged a show in the style of Bollywood movies, with both real Indian and real Pakistani film stars in it. This achieved our largest Asian audience until Tamasha came with a huge success called *East Is East* also directed by Kristine. This was essentially a very good, old-fashioned in structure, Lancashire comedy, but with an Asian paterfamilias in the heavy father role, running a chip shop.

This show went on to a West End run as indeed did Clarke Peters' *Unforgettable* which told the story of Nat King Cole. To date the Theatre Royal has not been successful in transferring one of its numerous, non-musical Black shows to the West End.

The most expensive show which the *Moe* money enabled the theatre to do was *It's a Great Big Shame* by Mike Leigh. His method of working from detailed improvisatory

rehearsals demanded four months rehearsal. He wanted particularly to write a piece set in Newham to play to an audience reflecting the working-class characters who were in the play. At my earliest discussion with him, Mike said, "Before you say it, I know, Philip. I've got to involve some black actors haven't I?"

In fact he involved four including yet another graduate of our youth group, Clint Dyer, who's kindly been my advisor on this essay. The two actresses went on to be in Mike's award-winning film *Secrets and Lies*. It was the first time Mike Leigh featured Black actors in his work. One of them, Marianne Jean-Baptiste, who had a leading role in the film, went on to be nominated for an Academy Award and then came up against an extraordinary piece of racism, which I'd imagine grew out of the kind of compartmentalisation in the brain that I owned up to earlier in this essay. The British film industry sent twenty leading young British actors to the Cannes Film Festival. Marianne was not included. Not to include someone who was at the time up for an Academy Award is beyond belief. No doubt whoever chose them automatically thought British means White. Marianne bravely went public in her protest on a cast-iron principle, but nevertheless was accused by the press of whingeing.

The major new trend in the nineties for the Theatre Royal was the emergence of the Black revue, which form grew by 1997 to almost over-dominate our theatre programming.

Old-fashioned West End revue died off in the early sixties, killed by the modernity of *Beyond the Fringe* and the immediacy of *That Was the Week that Was* on T.V. However in the nineties Stratford East staged ten Black and Asian revues, re-staged three of them for a second run and shepherded three of them into tours of Britain and the U.S.A.

These revues mostly consisted of sketches which could be up to twenty minutes long. Some had musical episodes, and had some consistent themes running through them. The theme they all had in common was the British Black or

Asian experience, principally of people in their twenties who were born here, which was the situation of most of the actors involved.

They were an expression of Black issues which were not normally aired in the media.

Similar revues grew on T.V. a couple of years after the Stratford East cycle of revues started and many of them had observable contributions from the Stratford East revues in subject matter, actors and writers.

How these revues started at Stratford East is worth recording.

A very talented Black actor in his thirties, Calvin Simpson, seemed set to make a big contribution in the years ahead to British theatre. However he was killed early one morning in a road accident in 1990, doing the kind of job, in this case a messenger, which actors often have to do to survive. His last appearance was in *Side Pockets* at Stratford East and so a benefit for his three children was held at the Theatre Royal.

That evening was inspiring for the fifty-odd Black actors and musicians who took part and many others in the audience, because it made visible the huge range and depth of Black talent that was now available in British theatre. For some it was also a source of anger because it was also remarked that much of that talent could not break through the glass ceiling of White administration and there was no Black producing theatre that owned its own building.

It so happens on that evening a group of talented Black actors in their late twenties concocted a sketch for the event at my suggestion. They improvised another for a second Black charity event later that year, and a seed was sown.

The following summer they wrote formally to me under the name of The Posse saying the time had come "to take the reins into their own hands" and they asked for a Sunday night at the Theatre Royal. They said they could show me no script and they wanted to write, produce, direct, market and act in their own show. They meant to direct as an eight-man team, something unheard of in theatre.

It was fascinating to me they should make such a suggestion. I cannot imagine an equivalent White group doing the same thing. Perhaps The Posse wouldn't have had the nerve to do so if all of them had not previously acted on our stage, but what was crucially different was the sense of cause they had to give voice to young Black British experience in an up-front populist form. One theme in the show was the type-casting Black actors were usually confined to. White casting directors and producers were sent up and the actors fulfilled ambitions such as playing cowboys. I didn't ask to see the show in rehearsal. However I was invited in to advise at a late run-through because "you're good at getting furniture on and off, Phil." Some of it I couldn't understand. Some of it I couldn't see why it was supposed to be funny. The audience could and raised the roof. Another lesson in trust learnt.

The show was a runaway success. It came back for three nights and then three weeks. It finally did a ten-week tour of Britain. The tour was illuminating. In half the theatres they brought in a large Black audience which had never been in a theatre before. In theatres less open to The Posse's up-front marketing techniques, they did less well.

The Posse knew it was word of mouth that would get people into a theatre for the first time. It had to be people to people, not paper to people, and so radio and going out and meeting people, chatting to them while handing out leaflets and visiting Black restaurants and barbershops was the way to do it. They and all the Black and Asian groups that followed them at Stratford East had a lot to teach White theatre administrators and not just about marketing for Black people.

The Posse were closely followed by an equally talented Black women's group, The BiBi Crew, who also went on to tour nationally and visit the U.S.A. A few years on Indhu Rubasingham, our resident trainee director at the time, gathered an Asian group of actors together to improvise and stage a revue telling of young Asian British experience, and finally in 1997 Femi Efulowoju Jr evolved a show based on African British experience.

Femi's show went on to tour Sweden, with enormous success but as I write he's having difficulty booking a British tour. Every step forward seems to be hard work. Touring theatres now accept that a Caribbean-based Black revue can fill houses but what about a show of African heritage? We are not yet even past the stage where a touring theatre will refuse a show because "we've already had a Black show this year", or the answer may be "We had a Black show last year. It didn't work.", with no acknowledgement that that particular show just may have been a bad one, or that the marketing technique may have been ineffective. To suddenly do just one Black show among a year of White work without a great deal of extra and different marketing is setting the Black show up for failure.

Alongside the group revues another series of Black revues grew up centred around a single comedy artist. Llewella Gideon, Angie Le Mar and Geoff Schumann all staged a version of the sketch shows they had written and staged elsewhere, but in circumstances where they had to do everything themselves right down to gathering props or sewing costumes. Stratford East offered them a full, professional staging with an experienced designer and full support staff.

Problems sometimes arise in these circumstances. The originating artist had to learn they didn't have to do everything and could let the competent staff get on with their jobs. The staff had to learn that these artists may be inexperienced in conventional theatre, they may want to rehearse at unconventional hours and they may not know theatre jargon but they were hugely talented and in some departments, notably marketing, their "interference" was hugely productive. Some staff never respected this. However the majority could recognise the talent and admire the commitment of a leading lady who'd also written the show, and yet was out leafleting the clubs at two in the morning.

Some of those who've written and performed in the Stratford East revues are now developing from them. A splendid duo from The Posse, Robbie Gee and Eddie Nestor, have formed their own company and stage a joyous romp of a show, called

Gulp Fiction which is half-way between revue and a straight play. Angie Le Mar is extending one of her sketches to a full-length play. I'm sure more plays, musicals and unorthodox hybrids are in the pipeline. Black and Asian talent has the confidence and experience to break the rules and come up with new forms of populist stage entertainment.

The Theatre Royal has found itself in a new role with regard to Black and Asian artists, nationally and individually. Nationally we became an informal agency for Black writers, directors, actors and designers. Theatre and T.V. companies phone regularly for recommendations. For individuals the theatre would set up training courses. Some of The Posse went on courses in budgeting, marketing, writing and even typing.

The Theatre Royal set up an Afro-Asian Directors' Course. Over a fortnight would-be directors, who sometimes were experienced actors, had sessions with leading directors, designers and technicians and directed professional actors in workshop productions. This was set up for the selfish reason that the Theatre Royal simply didn't have enough Black and Asian directors to call on. It worked. The majority of the directors went on to direct at the Theatre Royal or elsewhere, and it was followed by a second course with another ten would-be's. The director of our current tour of a revival of *Scrape Off the Black*, Michael Buffong, is a graduate of our Youth Group, The Posse and our first Directors' Course.

The Theatre Royal now has an extended family of Black and Asian artists many of whom regard the Royal as home, the place to which they can dare to suggest ambitious ideas and where they are sure of a hearing. They re-pay the Theatre Royal a hundred-fold with the vitality of their work and the audiences they bring in.

I'll finish with an apposite example, particularly appropriate to the play-text in this volume.

Ade Ikoli who appears in *Scrape Off the Black* is the son of Tunde Ikoli, the author. He came to the theatre on a work experience scheme, became an usher at fourteen years of age and then moved backstage, closer to the stage itself. He was

often on the follow-spot in the gallery, lighting the artists. Ade thought "I could do that." He teamed up with an actor at the theatre and during one year they wrote sketch after sketch for their own amusement. You'd see them writing in the green room, the dressing rooms and the bar. Ade's backstage, six-foot high locker filled up with scripts.

Finally they dared to show their scripts to me. A reading was arranged and the small invited audience greeted the raw material for a show with appreciative laughter. Ade was amazed at the response and was hooked for life. A director was attached to the project, the aforementioned Jo Martin, now a graduate of our first Directors' Course. The show went on, suitably called *Ready Or Not* and Ade got his Equity card as the co-leading actor and the co-writer along with his mate, Robert McKewley.

His story has become the inspiration for the Theatre Royal opening itself up even more and evolving many a scheme of education and training under the heading "I Could Do That". Ade and Robert worked with a large group from the very long list of young people for whom there's no room in our youth group, and produced a variety show from their own ideas at the end of a week. They go into schools to encourage kids to write. What better role models than two young people who've managed to get their own show on.

There are many hidden social and educational barriers preventing new audiences and new talent entering theatre. It should be everybody's job in theatre to break them down.

<div style="text-align: right">

Philip Hedley
Artistic Director
Theatre Royal Stratford East
August 1998

</div>

AN AUTHOR'S JOURNEY HOME

This publication of *Scrape Off the Black* marks my twenty-fifth year in the business. As a writer I have been blessed with a unique and multi-cultural heritage: my Mum is Cornish, my Dad Nigerian. I was born in Whitechapel. The East End is where I have lived and worked all my life. Its history and development have been at the heart of all my plays and films.

I left school in 1970 at the age of fifteen to work as a trainee cutter, in a clothing factory. My wage was all of seven pounds, ten shillings a week. Like a number of my contemporaries I had dismissed the idea of a formal education having any relevance to my future. I was proud of the fact that on leaving school I had not read a book. I didn't need, nobody needed, qualifications. There were jobs a plenty; in factories, the print and the docks. You just had to turn up for an interview and you got the job. I could not wait to leave school, go to work and become a man. Of course now, it is a decision I bitterly regret. Back then, I didn't care. There was a life to be lived and I was going to live it on my £7.50 a week.

Amid the whirr and buzz of the special machinists and overlockers going ten to the dozen, the whoosh and stamp of the Hoffman pressers, the dribbling, hissing steam of the under-pressers, the sparkling sharp blades of the cutting machines, factory life had a rhythm, a music of its own and I was the excited new and junior member of the band.

I'm not sure when the boredom and frustration set in. Maybe a year or so into factory life. I was sixteen, the brave new world wasn't all it was cracked up to be. Money or the lack of it was a constant source of irritation. I could never get enough together to dress the way I wanted. Consequently I lacked the courage or confidence to talk to girls, let alone ask them out.

At home things were not much better. My mother treated me like some kind of cash cow, demanding £3.50 of my take home pay of £5.50, which in itself was bad enough. But what was truly galling was that she still treated me like a kid. At the ripe old age of sixteen and with no more than six months

experience in a factory as a trainee, I considered myself a working man. I wasn't having any of this. I left home to live in an Uncle's flat in Petticoat Lane. I say my Uncle. He was no blood relative. In fact he was no relative at all. I hardly knew him. He was one of my Mother's ex-boy-friends. I had no plan or strategy. I left to chance my means of survival. At the age of sixteen you don't know smart from stupid. I now had to pay rent, buy electric, food and clothes. My excess income disappeared and with it my ability to socialise.

Where was my life heading? I had no qualifications and seemingly no future. I was trapped. The bars on the constantly steamed up windows of the factory were a perfect metaphor for my life and prospects. What little money I had left over from my wages, I would spend on a Saturday up West, watching movies. I could deal with the boredom and frustration of factory life, knowing that I could lose myself in the movies on a Saturday. I sat in the middle of the front row stalls. It was as though I was in and a part of whatever film I watched.

My trips to the movies convinced me of my destiny. I decided I was going to become an actor. Around this time I remember a controversy surrounding a T.V. drama about a mixed-race couple that was pulled from schedules on the grounds that the Great British Public was not yet ready to see a black man kissing a white woman. There were no East Enders, Del Boy, Desmonds or Lenny Henry. Cockney accents and attitudes, black faces and cultures were alien to the British media. I wasn't deterred. In my ignorant, ambitious seventeen-year-old way I thought I'd change all that.

I read an article about Charlton Heston in a movie magazine. He was in England to direct and star in a movie version of Antony and Cleopatra. The article was laid out in what I took to be script form. It was the closest I had been to a script. There was something magical about its layout. For some strange reason I convinced myself that if I could memorise and recite the article, I had a pretty good chance of being an actor. For the next three days when not working I studied the article. By the time I had committed it to memory,

I was in something of a dilemma. Who do I recite the article to? I couldn't do it in front of my mates they'd just take the piss. I had a brain-wave. I hadn't seen much of my Mum since I left home. I decided to go round, give her a couple of quid and casually slip in the recital of the article.

If my Mum wasn't pleased to see me, she was pleased to see the two pounds. She sat grumpily on her bed, smoking a fag, looking terribly bored. I guess because of the two quid she felt obliged to listen. I didn't care or notice. I was on one, alternately speaking the lines of Charlton Heston and the Reporter for five pages. At the end I proudly dabbed sweat from my forehead and asked "Well? D'you think I could become an actor ?"

My Mum shrugged her shoulders and exhaled a bored sort of "Hmmph". I excitedly pressed on "How would I go about becoming an actor?" "How the bleedin' 'ell would I know!" she bellowed. I guess my two pounds worth of goodwill had run out. I didn't mind. I'd gone in front of the toughest audience I could imagine and come through word perfect. I was overjoyed. I knew I was going to become an actor. But how to go about it? Who would know? I asked my best mate Taploe, he didn't know but suggested I ask Dan.

Dan was a middle-class, youth worker who lived in Cable Street. He ran a youth club, the Quango, that my mates and I used to attend. As is the wont of boys of a certain age, we were always in trouble with the police. Dan would get us lawyers, stand bail, provide a shoulder to lean on or cry on depending on how much trouble we were in.

Dan would take us to the cinema and give us books to read. It was Dan who gave me the first book I ever read all the way through. When I told him that I wanted to be an actor, he introduced me to Buzz Goodbody, a talented theatre director and a nice person. She gave me advice on drama schools and took me to the Aldwych to see Peter Brook's production of *A Midsummer Night's Dream* with Alan Howard, Ben Kingsley and Sara Kestelman.

I remember sitting in the stalls and being almost blinded by the light. Struggle as I might, I could not make head nor

tail of Shakespeare. The words just went over my head, but I was mesmerised with the tightrope walking, the spinning plates. Sooner or later I thought plates and people are going to come crashing to the ground. The night I went nobody fell. After the show Buzz took me to meet the cast in the bar of the Waldorf Hotel, next door to the theatre.

I was really bitten. I started going to the theatre: *Romeo and Juliet* at the Shaw Theatre with Simon Ward & Sinead Cusack. Peter Coe's production of the Black *Macbeth* at the Roundhouse. I went by myself and bought the tickets. A lot of my mates took the piss. They thought I was whistling down the wind. As far as they were concerned I was a dreamer.

I enrolled with the local Amateur Dramatic Society at Toynbee Hall. The group was made up of middle-class city types, wanna-be actors, living out their theatrical fantasies. I think I was the only cockney. I was definitely the only black person, this caused the tutors problems with their casting policy. At first my colour was ignored, there weren't that many parts for black people or so they told me. During the day I was a tailor's cutter, at night I acted in Pinter, Coward and bizarrely a Scottish school teacher in *The Prime of Miss Jean Brodie*.

The next production caused a mutiny and near riot. Our tutors selected *The Insect Play*, which they must've thought neatly side-stepped the issue of my colour. All the characters are various insects. I guess it was metaphorical. I had not read the play and the group weren't having any of it. There was a rebellion, nobody was keen on playing insects. I am ashamed to say that I was in total agreement with them. Playing beetles, ants and flies didn't have the glamorous cache and kudos we obviously joined the group for.

They wanted Pinter, Beckett, a Feydeau farce, a Pirandello. I knew none of these authors but I was fed up playing what were obviously white middle-class parts. I was desperate to play something heroic and black. I was told there were no suitable plays by or about black characters.

I took them at their word and decided to do something about it. It was then that I started writing *My Way*, a musical

about a singing window cleaner called Trevor. I presented the first draft to the group. I cannot believe the arrogance and balls of my seventeen-year-old self. The group of course turned it down. There was only one decent part, that of Trevor. My part. With rejection ringing in my ears, I left the group in disgust but continued to write and dream of being an actor and writer.

It was about this time I went to see *The Godfather* for the first time. Marlon Brando was my hero. My brother, who had recently been released from Borstal was staying with me at the time. We had discussed the book in great detail and eagerly awaited its premiere. Everything you saw in those days whether on telly or in the cinema were one-off deals. You couldn't record the football, while watching *Coronation Street* on the other side. If you missed a film's London run you couldn't hire it from the video shop the next day. Videos had yet to be invented.

It was 1972, Edward Heath was Prime Minister. The Miners' strike was just around the corner. Nelson Mandela had only just started his life sentence. Twenty Rothmans were four and eleven. There was just three channels, no satellite, cable or video. And I still had an afro.

My brother and I went to see *The Godfather* five nights running during the first week of its release. *The Godfather* was all we could think or talk about. Since we could not relive the experience on video, we had to recreate it ourselves. With what now seems cumbersome, almost antique tools: the humble push-button cassette recorder and an old record player to play the sound-track album as background music, my brother and I would act out and record scenes from the film. *The Godfather* was a kind of watershed for me. The story of three generations of an Italian immigrant family establishing themselves made me realise that I could write about my own experiences. I stopped writing Hollywood-type musicals about window cleaners and started writing more hard edged stories based on the realities of my own experience.

In 1973 I wrote a script about a group of friends who were constantly harassed by the police. As pay-back they decide

to rob a bank next door to a Police Station. The script was made into a film called, somewhat originally, *Tunde's Film*.

As a result of that film I was offered a job as an assistant-director at the Royal Court Theatre. A combination of a little talent and a lot of luck, I guess. Oscar Lewenstein was the Artistic Director. I assisted Albert Finney who directed Joe Orton's *Loot*. More importantly I became Lindsay Anderson's personal assistant on his filming of his own production of David Storey's play *In Celebration*. Filmed at Borehamwood studios. The cast included Alan Bates, James Bolam, Bill Owen, Brian Cox and Constance Chapman. Lindsay was a truly great director and person. I had the time of my life and learnt so much. David Storey's wonderful play was about a group of brothers gathering at the family's home in the North to celebrate their parents' 50th wedding anniversary. I was inspired. After a day in the studio I went home to write. I started writing a play about my brother, my mother and me.

That play became *Scrape Off the Black*. It was commissioned by the Royal Court, but originally produced at Riverside Studios under Peter Gill's direction. Since then the play has gone through many changes and productions. But it wasn't until it reached the Theatre Royal that I felt it fulfilled its full potential. It is as though it had come home. The great irony of my career was that in its first fifteen years I had never had a play on in the East End, not until Philip Hedley's production of *Scrape* was produced at the Theatre Royal, and I was relieved to have found my theatrical home.

There has been no comparable feeling in my career than standing at the back of the upper-circle with a packed Theatre Royal audience listening to the words of my play, while a couple sitting directly in front of me argued about its content.

I hope you enjoy this production of the play.

Many thanks to Philip, Kerry, Michael and Sylvie.

This play is dedicated to Ade (brother), Ade (son), Tunde (son), Tunde (dad) and Nicola (daughter). Love.

<div align="right">Tunde Ikoli</div>

"The Theatre Royal remains a splendid example of the vitality of the theatre."

Evening Standard

"The Theatre Royal Stratford East was made famous in the 1950s by the Theatre Workshop Company led by Joan Littlewood and Gerry Raffles. Under the present leadership of Philip Hedley, in a time of restriction and entrenchment in the arts, they have increased their programme, developed an enthusiastic multi-racial audience of every class and age group, and most successfully promoted new writing with particular emphasis on populist, Afro-Asian, and young people's work. This is an extraordinary achievement for a theatre of such substantial size but with restricted resources."

**Judges Citation –
Prudential Award for Theatre 1990 Winner**

"As every theatre director knows, staying on the tightrope in the current climate demands extraordinarily canny programming. The Theatre Royal Stratford East is a splendid example of just that. It constantly overhauls its profile to reflect the concerns and tastes of its hugely varied East End constituency. The Artistic Director Philip Hedley has been placing the initiative in the hands of young local artists. Hot on the heels of two young Black groups comes D'Yer Eat With Your Fingers?!, *a show by Young Black Asians. The first night was buzzing with YBAs, but not exclusively, and this is perhaps the most important thing about such programming: audiences learn about other cultures."*

The Independent

"If your experience of theatre-going lies in the West End, you hardly know the half of what live theatre can be. The great marvel of the Theatre Royal is its audience, which is harmoniously multi-racial, largely working-class and highly appreciated."

The Financial Times

"Stratford East audiences are generally marvellous. Indeed, if I was compiling a good audience guide, they would go top of my list."

The Guardian

The Theatre Royal was named as a role model case study by the Commission for Racial Equality in 1997.

SCRAPE OFF THE BLACK

Characters

ROSE

TREVOR
her elder son

ANDY
her younger son

MARY
her neighbour and best friend

SCRAPE OFF THE BLACK received its first production at the Riverside Studios on 12th July 1980 with the following cast:

ROSE, Mary Macleod

MARY, Susan Porrett

TREVOR, Brian Bovell

ANDY, Okon Jones

Director, Peter Gill

Designer, Allison Chitty

The play was first performed at the Theatre Royal Stratford East on 6th February 1987 with the following cast:

ROSE, Jill Gasgoine

MARY, Kate Williams

TREVOR, Gary MacDonald

ANDY, Chris Tummings

Director, Philip Hedley

Designer, Andrea Montag

It was revived by the Theatre Royal Stratford East on 18th September 1998 with the following cast:

ROSE, Chrissie Cotterill

MARY, Su Elliott

TREVOR, Craig Blake

ANDY, Ade Ikoli

Director, Michael Buffong

Designer, Marsha Saunders

*ROSE's flat. The living room. Early morning. The curtains are drawn,
light from a crack in the curtains, barely brightens the darkened
room. In the half-light, we can just make out the figure of ROSE,
sitting on the sofa, feet up, telephone by her side, she smokes a cigarette,
while looking at a small framed photograph, occasionally she flicks a
lighter on and off, lost in thought. A record: "From a Jack to
a King" plays on the radiogram. A knock at the front door. ROSE
startled, snuffs out the flame on the lighter. She gets up and hobbles,
limps to her bedroom off. She comes back out almost immediately, as
shedoes the door is knocked again.*

ROSE: Bastard! Stupid. Sodding. Bastard. Every morning...
Every day... Can't I have some bloody peace...?

*She angrily stubs out her cigarette, her leg starts giving her pain,
she snatches the needle off the record, silence, the door is knocked
again.*

ROSE: (*Bellows.*) Wait a bloody minute!!! Ouch... Poxy leg!
I'll kill him. I will I'll kill him.

*She slowly limps off to the front door. Empty stage, we hear
ROSE opening the front door.*

TREVOR: (*Heard. Off.*) Good Morning, Mother.

ROSE: (*Heard. Off.*) Good. What's good about it?

TREVOR: (*Heard. Off.*) The sun is shining, the sky is...

ROSE: (*Heard. Off.*) Why don't you shut up!

TREVOR: (*Heard. Off.*) Right.

ROSE re-enters followed by her son TREVOR.

TREVOR: Did I wake you?

ROSE: Yes you bleedin' did! You got no business coming
round this time of the morning. Disturbing me I get
precious little sleep as it is.

TREVOR: Sorry. I was passing... thought I'd call in.

ROSE: What do you want?

TREVOR: Nothin' but your company...

ROSE: Piss off.

TREVOR: Your leg playing you up is it?

ROSE: Never you mind about my leg. I've got no money.

TREVOR: I don't want your money... (*About to open curtains.*)

ROSE: Leave 'em!

TREVOR: Why?

ROSE: The loan man's due...

TREVOR: So?

ROSE: You being stupid or what? I keep the bastard curtains closed, because I don't want the loan man looking through my window and seeing I'm in.

TREVOR: Shall I switch the light on?

ROSE: Why?

TREVOR: It's dark.

ROSE: No it's not...

TREVOR: I can't see...

ROSE: Switch the bloody light on, if you want.

TREVOR switches the light on, the contents of the living room are revealed, colour television, 3 piece suite, fitted carpet, formica-topped radiogram. ROSE in a nightdress, hair a mess.

TREVOR: That's better...

ROSE: Why ain't you at work?

TREVOR: I packed it in...

ROSE: You've not been there a week.

TREVOR: Packin' boxes all day. I'd had enough of it.
I need somethin' more fufillin'. Somethin' that taxes
my brain...

ROSE: What brain?

TREVOR: Funny...

ROSE: And what's 'She' got to say about it?

TREVOR: 'She', the Mother of my son, the lady I love;
'She' has got a name Mum; Marcia. And sh... Marcia
won't say anythin'.

ROSE: Have you told her?

TREVOR: No... er... not yet. So... has he phoned?

ROSE: Who?

TREVOR: Come on Mum...

ROSE: No, he hasn't phoned.

TREVOR: Aren't you lookin' forward to seeing him?

ROSE: 'Course I am but all I can see is the same old
trouble.

TREVOR: It's been over a year, he'll have changed...

ROSE: That boy's set in his ways. No amount of beatings
or punishments is going to change him.

TREVOR: We should really try and make things different
for him this time...

ROSE: I've done all I can...

TREVOR: Yeah... sure...

ROSE: Don't you start your cheek with me.

TREVOR: I'm not. I'm agreeing with you...

ROSE: He never gave me anything. What did he ever give me, except trouble?

TREVOR: What did you ever give him?

ROSE: I'm his Mother. I gave him life, what more am I supposed to have done?

TREVOR: Shall I make some tea?

ROSE: If you want.

TREVOR: And toast...?

ROSE: Haven't you got any food at home?

TREVOR: 'Course. I'm peckish. That's all...

ROSE: She's not feeding you properly.

TREVOR: Slice a toast is all we're talking about here...

ROSE: Alright. Go on then. (*TREVOR's already gone off into kitchen.*) Just two slices mind and when you make the tea, use one tea bag between the two of us...

TREVOR: After I've done that shall I hang it out on the line with the other tea-bags...

ROSE: I've warned you about your cheek, if you're gonna take the piss, you can forget about the tea and toast and get out!

TREVOR: Okay, okay, it was joke. (*He goes off to kitchen.*)

ROSE: As you're eating my bread, you can do a slice for me.

TREVOR: (*Heard. Off.*) I've put one on already...

ROSE: Don't let it burn...

While he is out of the way ROSE quickly and furtively takes the majority of her cigarettes from the packet and hides them in her handbag.

TREVOR: (*Heard. Off.*) In all the years that I've been making toast for you, have you ever known me to burn a single slice?

ROSE: There's always a first time...

TREVOR: (*Coming back on.*) You've got no confidence in me...

ROSE: (*Has hidden her fags in time.*) How's little Trevor?

TREVOR: He's alright. At home with his Mother...

ROSE: Andy wrote and told me how pleased he was to be an Uncle. You should've taken the baby up on visit...

TREVOR: Marcia didn't think a borstal was the right environment for a baby...

ROSE: How bloody daft can you get. I took you and your brother up to Wormwood Scrubs to see your Father, when you was babies.

TREVOR: And look how we turned out...

ROSE: You turned out alright... It'll be over a year since I last saw him. He was standing right where you are, two minutes and the police kicked the door in and...

TREVOR: I offered to take you on a number of visits.

ROSE: It was me bad leg, playing me up something awful, it was. Couldn't move.

TREVOR: Didn't stop you going to bingo...

ROSE: The toast!!!

TREVOR: The toast?

ROSE: Don't you dare let it burn! (*TREVOR dashes off.*) If it's burnt you'll just have to scrape off the black, don't you dare throw it away. If you wasn't so busy sticking your nose in other people's business, you'd know what you were doing.

TREVOR: (*Coming back on.*) It's alright I've turned it over...

ROSE: You'd better stay in the kitchen with it.

TREVOR: It'll be alright...

ROSE: I'm warning you. If it burns. That'll be the last slice of toast you get off of me...

TREVOR: Mum it's on a low light, the toast will not burn.

ROSE: Better not. Ouch...

TREVOR: Leg?

ROSE: (*Nods.*) It's the cold...

TREVOR: It's not cold in here...

ROSE: Don't stop the cold from outside getting to it does it. I can feel it. My bad leg turns funny whenever the cold weather is coming on.

TREVOR: Like a barometer, you can predict the weather with your leg. You ever thought about becoming a weather forecaster?

ROSE: You trying to be funny?

TREVOR: Wouldn't dream of it...

ROSE: 'Cause I don't think it's funny, laughing at my leg.

TREVOR: No. Sorry. You're right. You know what you should do; put yourself to bed for a couple of days, give the leg a rest.

ROSE: And who's going to do the housework?

TREVOR: I'll do it...

ROSE: I like to do it myself, then at least, I know it's going to be done properly.

TREVOR: Mum you can be honest with me. It's the bingo isn't it, you're frightened you might miss a couple of sessions...

ROSE: Can't afford not to.

TREVOR: You talk as though bingo is a guaranteed income which I can't understand because you never win...

ROSE: You tell me where else I'm going to get the money to pay off me debts...

TREVOR: But isn't bingo just making you more in debt?

ROSE: The toast!! (*He dashes off to the kitchen.*) Is it burnt?

TREVOR: (*Heard. Off.*) No...

ROSE: You sure?

TREVOR: (*Heard. Off.*) 'Course I'm bloody sure...

ROSE: Don't you start swearing at me!

TREVOR: (*Heard. Off.*) Bloody ain't swearin.

ROSE: Yes it bleedin' is, as far as I'm concerned!

TREVOR enters with tea and toast on a tray, he serves his Mum.

TREVOR: Your toast madam, completely unburnt.

ROSE: I hope you haven't put too much butter on it...

TREVOR: Well?

ROSE: What?

TREVOR: Two little words...?

ROSE: Piss off.

TREVOR: I was thinking more along the lines of thank you. But piss off will do.

ROSE: It was my bread, my tea, my milk.

TREVOR: But I made it...

ROSE: So you should. I'm your Mother.

TREVOR: Where would you be without me?

ROSE: A lot better off.

TREVOR: What down in Cornwall, the wife of a farm labourer, up at the crack of dawn, milking cows and picking potatoes. Your leg would have never lasted out.

ROSE: My leg would have been just fine. I'd've been happy.

TREVOR: But Mum you'd've never had us.

ROSE: Bloody good job.

TREVOR: You got any fags?

ROSE: You come round here to scrounge?

TREVOR: No...

ROSE: Smoke your own.

TREVOR: I haven't got any...

ROSE: (*Showing him the contents of her near empty pack of cigarettes.*) I've only got a few. You can only have one.

TREVOR: Clever as I am, I can only smoke one at a time.

ROSE: You'll get no more.

TREVOR: (*Taking fag.*) That's what I love about you Mum, so generous, so willing to give.

ROSE: Light it off mine. I'm not wasting a match.

TREVOR: Wouldn't expect you to...

ROSE: And don't puff mine.

TREVOR: (*Handing back fag.*) I'll buy you some later...

ROSE: That'll be the day.

TREVOR: I promise.

ROSE: Heard your promises before.

TREVOR: Anyway, by rights you should give 'em up, you can't afford it living on the social and they're bad for your health.

ROSE: Go on piss off. Why don't you bloody give it up, then you wouldn't need to smoke mine. I don't know what the world is coming to nearly a pound for a packet of fags...

TREVOR: Not like the old days eh?

ROSE: You're right there... I can remember my Dad buying ten woodbine and still having change out of two shillings. Use to cough his little heart out he did. (*She smiles to herself.*)

TREVOR: I don't know why you ever left Cornwall.

ROSE: I know why I did. It's now that I wish I hadn't. D'you know when I wrote and told my parents I had had a kid to a black man, I got a letter by return post with the train fare, begging me to come home with you. As if they could save me.

TREVOR: Why didn't you go...?

ROSE: Spent the money on a lovely siren suit for you.

TREVOR: You should've gone, taken me while you had the chance.

ROSE: It was your father. I really did love your Dad in those days. Couldn't imagine life without him. Fool that I was...

TREVOR: If you'd taken me back, I would have been the only black yokel in the West Country.

ROSE: You're not black.

TREVOR: I'm not white...

ROSE: You're half-caste.

TREVOR: If you say so...

ROSE: What are you after...?

TREVOR: After...? Me...?

ROSE: You've been acting strange all morning. Agreeing with me, no backchat, making me talk about my past. You want something or you're up to no good, you sly bastard.

TREVOR: It's a sad, sad, day when a son can't be kind to his own Mother without her...

ROSE: I've already told yer, I've got no money.

TREVOR: I've got my own.

ROSE: So why didn't you buy fags?

TREVOR: Didn't have time, I came straight here.

ROSE: I don't believe it. Money on Monday morning. Not you.

TREVOR: I've bin savin up...

ROSE: What for?

TREVOR: Today...

ROSE: What's so special about... So, how much you got?

TREVOR: Enough.

ROSE: For what?

TREVOR: What I need.

ROSE: Where d'you get it?

TREVOR: That's my business.

ROSE: You haven't been up to anything silly have you son?

TREVOR: Who me, na...

ROSE: So what you up to?

TREVOR: I just thought I'd hang around, keep you company.

ROSE: What's the matter, she kicked you out again.

TREVOR: No. Nothin' like that.

ROSE: I don't want you at me feet all day, driving me mad.

TREVOR: I thought we'd have a party...

ROSE: A party? Why?

TREVOR: Celebrate Andy's release.

ROSE: Where?

TREVOR: Here?

ROSE: No. Oh no. No way.

TREVOR: Not a big party.

ROSE: No.

TREVOR: In fact a very small party... just family...

ROSE: What family?

TREVOR: Our family.

ROSE: Like who?

TREVOR: You, Andy, me... You know all of us together,
 a family. Go on Mum. Just for Andy.

SE: I've got enough troubles without having the two of you in the same room as me...

TREVOR: I'll give you the money to go to bingo this afternoon.

ROSE: It's four pound.

TREVOR: No problem.

ROSE: How much money you got?

He makes a big show of pulling three crumpled fivers out of his pocket. ROSE deeply unimpressed.

TREVOR: Fifteen quid!

ROSE: Is that it. Is that what you call money?

TREVOR: What would you call it?

ROSE: Way you was going on, I thought you had a couple of hundred...

TREVOR: Where am I going to get that sort of...

There is a knock at the door. TREVOR and ROSE freeze.

TREVOR: Who's that?

ROSE: How would I know, I'm not outside am I... Switch the light off, switch the light off...

TREVOR: (*Switches light off.*) Andy?

ROSE: Na, it's not his knock.

TREVOR: How can you be so sure? It's over a year since, you last heard his knock.

ROSE: I know my son's knock!

TREVOR: Shall I get it?

ROSE: No... Yeah... wait... If it's Andy, he'll call. (*They wait in silence. The door is knocked again.*) I wonder who it is?

TREVOR: We won't find out, if we don't open the door...

ROSE: If it's the loan man, tally-man or tele-man, tell them I'm not in and I'll see them next week...

TREVOR: I could pay him for you...·

ROSE: Don't you dare I want that money for bingo. Now open the bloody door.

TREVOR: Yes sir. (*He salutes as he marches off.*)

ROSE: Bugger... (*ROSE looks in her cigarette box; no fags. In frustration she screws up the box, then remembers the fags in her bag. TREVOR comes back on.*)

TREVOR: The loan man says he can't wait till next week, he wants payin' now. So I let him in.

ROSE: (*Livid. Struggles up from the sofa.*) You little sod!

In walks MARY, mid-40s, looks older, a little unsteady on her feet, a once striking woman, has fallen on hard times. Her coat and dress are remnants of a glorious well-dressed youth, she makes an effort, her hair is coiffured into a beehive.

MARY: Hello love.

ROSE: Oh it's you.

MARY: Who was you expecting? Your fancy man?

ROSE: Do me a favour. I need a fancy man like I need a hole in the head...

MARY: Sorry... what... a hole in the head Rose?

ROSE: Sit down Mare, take the weight off your brain...

MARY: Thanks love. When I had to knock three times, thought you were out, gone to the Post office...

ROSE: It's this bastard pissing about...

TREVOR: Mum and Dad weren't married. Did you know...?

MARY: Not everyone feels the needs to those days...

ROSE: Take no notice of him, he'll drive you mad.

MARY: He's getting so big...

TREVOR: It's only a couple of weeks since you last saw me. I must grow very quickly.

ROSE: Only your head.

TREVOR: Take after my Mother.

ROSE: You'll take the back of my hand. (*To MARY.*) Cup a tea?

MARY: If it's not... no trouble...

ROSE: No trouble. (*To TREVOR.*) Make Mary a cup of tea love.

TREVOR: 'Love' now is it? Now you want somethin'...?

ROSE: Just shud up and make the tea...

TREVOR: Shall I use a fresh bag or one of the used ones hanging on the line...

ROSE: I'm warning you...

MARY: That's a good idea, you've got to do what you can to save money these days...

ROSE: What are you talking about Mary?

MARY: Hanging the tea bags on the line. I hadn't thought of.

ROSE: Take no notice of him Mary, he's not right in the head.

TREVOR: You wanna be careful, you might give people the impression that you don't love me.

ROSE: Go and make the bloody tea! (*TREVOR goes off.*)

MARY: Spittin' image of his Father...

ROSE: To much for my liking . Every time I see that one, I see his Father!

MARY: Your Trevor was a lovely looking man...

ROSE: That he was. But it's the memories Mare...

MARY: Yeah, the good old days...

ROSE: I'm not talkin' about the good old days. Living with that man, his Father, was a nightmare...

MARY: Ooooh it was Rose, a nightmare...

ROSE: So what happened to you last night? I missed you at the late session?

MARY: (*Blushes.*) Well...

ROSE: So you let him go home with you?

MARY: It had been a long time Rose...

ROSE: What was he like then?

MARY: Nothing special. Left this morning without a word, television went with him...

ROSE: You're a silly cow!

MARY: I know.

ROSE: Haven't you learnt yet? None of 'em are any good.

MARY: Oh no Rose, he wasn't black. This was an Englishman...

ROSE: Black, white, yellow, brown, what ever the size or shape, there's not one of them that's any good...

MARY: 'cept your Father...

ROSE: Yeah, right...

MARY: And your brothers...?

ROSE: Yeah...

MARY: And your sons...?

ROSE: I wouldn't know about that... Anyway you know what I'm trying to say. None of the ones we've ever met have been any good. After all you'd been through, I would have thought that you would have known better. You had it all Mare...

MARY: Ooooh don't go on so Rose...

ROSE: A beautiful house, money in the bank. Now look at yer!

MARY: Easy come, easy go...

TREVOR entering with tea, which he hands to MARY.

TREVOR: You can say that again...

ROSE: Nobody was talking to you...

MARY: Thanks pet.

MARY takes a syringe out of her bag and prepares to stick it in her arm. TREVOR feigns shock.

TREVOR: I didn't know you were a junky?

MARY: I'm not. I'm diabetic.

TREVOR: I know. D'you have to do that every day?

ROSE: 'Course she does.

TREVOR: Don't it get on your nerves?

MARY: You get used to it...

TREVOR: What'd happen if you didn't take it?

ROSE: Mind your own. Go and make me another cup of tea.

TREVOR: What did your last slave die of...?

ROSE: Well it wouldn't be overwork in your case would it?

She holds her cup, which after a pause he takes and goes off.

MARY: He's a good boy.

ROSE: There's a lot of things I could call him but good boy would not come top of the list. He's like a fart in a thunder-storm, he don't know his arse from his elbow, that boy's had more jobs than you and I have had hot dinners. He'll never amount to anything. Kids are alright as babies and at school but after that forget it.
My Andy's due out today...

MARY: Out? Out of where love?

ROSE: Prison. Borstal. Heavens forbid.

MARY: I thought you'd be pleased...

ROSE: At least while he was inside, I'd know where he was...

MARY: Perhaps it'll have done him some good...

ROSE: Can't see it Mare. Last time he came out, wasn't more than a week before he was up to his old tricks.

MARY: Shame...

ROSE: A bloody shame.

MARY: And he's such a nice boy...

TREVOR: (*Coming on with tea.*) Talking about me again...

MARY: So your brother's free today?

TREVOR: Great news eh?

MARY: Always been close haven't they... then they usually are, aren't they, brothers and sisters, sisters and brothers as well... families... It must be wonderful having your family around you.

TREVOR: That's what I say...

ROSE: Nobody's interested in what you've got to say...

MARY: I had a sister... Alison... (*Pause.*)

TREVOR: Well? What happened to her?

MARY: I don't know...

TREVOR: You don't know what happened to your sister?

ROSE: Leave Mary alone...

MARY: ... Last time I saw her, she was eleven... I was fifteen, leaving home heading for the bright lights of London 'Bye' I said, 'When I'm rich I'll send for you...' 'Course I never did.

TREVOR: Where was home?

MARY: Scotland... (*ROSE kisses her teeth, irritated, not being centre of attention.*)

TREVOR: You ever been back?

MARY: Ooooh no... never... I can't...

TREVOR: Why?

MARY: It's a long story...

ROSE: And we don't have time to go into it now. Do we Mare?

MARY: Don't we?

ROSE: No we don't. We're having a party.

MARY: That's nice, can I come...?

ROSE: Of course...

TREVOR: Not a party, more of a family reunion you, Mum, Andy...

MARY: Oh... I wouldn't want to intrude...

ROSE: You won't.

TREVOR: It was meant to be just family...

ROSE: It's my house and I'll say who's coming and who's not.

MARY: But there'll be things you want to talk about...

ROSE: What bloody things?

TREVOR: Family things...

MARY: And I've got to wash the cats...

ROSE: You're coming and that's that.

TREVOR: They should have let him out of the gates by now...

MARY: On his way to see his Mum...

ROSE: He always comes to see me first...

MARY: You must be so proud...

ROSE: I don't know about proud, after all he has just been released from borstal. More pleased I'd say.

MARY: It's only natural. You being his Mother... Andy was always your favourite...

TREVOR: What about me?

ROSE: You didn't need it. Your Father gave you more than enough attention...

MARY: Would be wouldn't it with Africans, first born and all that. Just imagine if their Father hadn't gone to prison that time, you might be still together...

ROSE: Biggest slice of luck I've ever had. I'd've had twenty one kids by now. I took my chance when he went inside,

I would not have had the nerve to leave him, while he was out...

MARY: They could be bastards those Africans...

ROSE: Couldn't do anything I wanted. Had to breast-feed the both of them. Didn't dare say, I didn't want to. Had no say whatsoever in their names...

MARY: But when they first arrived in this country they were lovely men. Always willing to take you out to pubs or parties, they knew how to have a good time...

ROSE: When I first met their Father gentle as a lamb he was, I'd just come up from Cornwall, green as the grass I was. He gave me some money for house keeping. I went out and spent it all on chocolates...

MARY: Oh Rose you didn't...

ROSE: I did. I didn't know any better. He said get some food and I liked sweets...

MARY: What did he do?

ROSE: Nothing, he just laughed. Didn't laugh the next time though, gave me a clout...

MARY: Cruel...

ROSE: At times... but it's in their nature...

TREVOR: 'Ark at you two. Slept with a couple of black men and you're world renowned experts on Africans. You two should be on Mastermind; Tonight we have Rose and Mary from the East End of London and their chosen subject: the cultural, social and sexual mores of the African man in London 1949 to 1968...

ROSE: I know all there is to know about Africans...

TREVOR: If my dad was so cruel why didn't you leave him and find yourself a nice Englishman...

ROSE: Me go with an Englishman...? Don't be silly. (*MARY laughs.*)

TREVOR: Why?

ROSE: I couldn't bring myself to.

MARY: Once you've tasted the sweet, you don't want the bitter.

ROSE: And what Englishman would have looked at me with you two darkie children, trailing behind me...

MARY: Once you've been with a black man, Englishmen think you're only good for one thing...

ROSE: You kids have been a scar on me...

TREVOR: I need a fag...

ROSE: Not off me...

TREVOR: Mary'll give me one. Won't you Aunty Mary?

MARY: I've only got these, they're non-tips...

TREVOR: I'm like me mum, I'm not fussy (*He takes fag.*) You're lookin' really nice Mary, hair all done up. Goin' somewhere?

ROSE: She's going to bingo with me.

TREVOR: Bit early for bingo isn't it?

MARY: The morning session...

TREVOR: Bloody hell. Don't you get bored with it, morning, noon and night?

ROSE: Better than listening to you prattling on.

TREVOR: Why don't you just pay your debts and have done with it. This salvation through bingo is just a sad illusion.

ROSE: You're full of shit.

TREVOR: Charming...

ROSE: I want you to go to the post office for me...

TREVOR: Your wish is my command oh wicked, white, witch...

ROSE: You're going to get a clump you are...

TREVOR: You love me really... (*He is about to bend down and kiss ROSE, when the door knocks.*)

MARY: D'you think that's Andy?

ROSE: It's not his knock...

MARY: Isn't that wonderful, a mother knowing her son's knock.

ROSE: (*To TREVOR.*) Answer the door. Remember what I told you.

TREVOR: Yeah, you want me to lie...

ROSE: I'll pay them next week! (*TREVOR goes off. ROSE signals for MARY to listen at the door.*)

ROSE: Who is it? What's he saying?

MARY: It's Blundel. Nice wee Jewish man. So many folk owe the poor man money...

ROSE: If he's fool enough to offer it. What should I do?

MARY: I haven't paid him for a month... Oohhh err... (*MARY quickly moves away from door as TREVOR enters.*)

ROSE: What took you so long? Tell him your life story?

TREVOR: I made up some story about your leg. Said you was in hospital. He was after coming to visit you...

ROSE: He just wants to collect his money.

TREVOR: No, I don't think so, he seemed to care...

ROSE: All he cares about is his money...

TREVOR: I felt sorry for him. So, I give him three quid.

ROSE: (*Struggling up from the sofa.*) You're daft as bloody arseholes you are. Blundel see you coming a mile off...

TREVOR: What?

ROSE: You're too bloody soft. (*She limps towards her bedroom.*) Better not have been my bingo money.

TREVOR: It wasn't...

ROSE: There'll be no party if it was.

TREVOR: It wasn't. (*Takes a fiver from his pocket.*) Here's your money... (*ROSE snatches the fiver before TREVOR can change his mind.*) You said four pounds...

ROSE: The other pound's for the cab. (*ROSE goes into the bedroom slamming the door behind her.*)

TREVOR: She's got some front ain't she?

MARY: She's a lovely woman... (*Taking a bottle of vodka from her bag unscrews the cap.*) When are you expecting Andy?

TREVOR: Any time...

MARY: I'll have a wee sip to celebrate his release. D'you want some? (*Offering TREVOR the bottle.*)

TREVOR: It's a bit early for me. But you go ahead...

MARY: Don't say anything to your Mother, she'll do her nut.

TREVOR: Take no notice, her bark's worse than her bite...

MARY: I wouldn't be too sure about that...

TREVOR watches in astonishment as MARY takes a large gulp from the bottle of vodka. Slow fade to blackout.

Sometime later. Lights up. TREVOR alone, it is obvious he has been tidying up for his Mother; cleaning apparatus lays around, furniture polish, cloth, bucket, bex-bissel carpet-sweeper. TREVOR cleans and sweeps, dances as he does, to record playing on radiogram, he sings along using the handle of the bex-bissel as a microphone. TREVOR waits for the next record to fall, he prepares himself, like a singer in front of an audience.

TREVOR: Ladies and Gentlemen, live and direct from the U.S.A., I want you to give a loud round of applause for Mr O C Smith...

O C Smith's "Hickory Hollers Tramp". TREVOR sings along with some passion, the theme of the song and his performance almost bring him to tears.

TREVOR: (*Singing.*)

"Oh the path was deep and wide from footsteps
leading to her cabin...
Above the door there burnt a scarlet lamp and,
Late at night a hand would knock and
There would stand a stranger...
Yes I'm the son of Hickory Hollers Tramp..."

"Last summer, mumma past way and
Left the ones who loved her,
Each and every was more than grateful for their birth
Each sunday she receives a fresh bouquet of 14 Roses
And a card saying the greatest mom on earth..."

Banging on front door. Startled TREVOR stops singing. He dabs sweat from his eyes and quickly, sweeps away all the cleaning things, switches the radiogram off, he surveys the scene making sure everything is in its place. He goes off.

ROSE: (*Heard. Off.*) What took you so bloody long?

TREVOR: (*Heard. Off.*) Just tidying up...

ROSE: (*Heard. Off.*) Has he been.

TREVOR: (*Heard. Off.*) No. You seen him?

ROSE and MARY, in their coats, followed by TREVOR enter.

ROSE: Don't be bloody daft. What's he going to be doing at the bingo hall?

TREVOR: Any luck?

ROSE: Luck. Huh. What's that? Something every other sod in the world has except me...

MARY: You nearly won though Rose...

ROSE: Nearly's not going to pay my bleedin' bills is it?

MARY: No, I suppose not...

ROSE: It's that poxy Vera, she's the one with all the luck and it's not as though she really needs the money. When she called out: "Here-are" on the last house, I could have stubbed my cigarette out on the back of her neck. She has too much luck if you know what I mean...

MARY: Er... yeah...

ROSE: There's something dodgy going on...

TREVOR: Not a fix?

MARY: That Vera wins practically every night...

ROSE: Her and the Manageress are lesbians...

MARY: I never knew that...

ROSE: They must be. How else is Vera winning so often? Nobody should have that much luck.

TREVOR: Mum, please, you're such a bad loser. You should learn to accept defeat with dignity. Like what I do...

ROSE: That's because you've had so much bloody practise...

TREVOR: That's because I've had such a wonderful teacher...

ROSE: You gotta go to the post office for me.

TREVOR: I was just on my way...

ROSE: Get a move on then, instead of standing about nattering like some old woman...

TREVOR: I was going to have a cup of tea...

ROSE: Now!

TREVOR: After all I have just finished doing the house work...

ROSE: Now!

TREVOR: You want me to go to the Post Office now?

ROSE: You little bastard!

TREVOR: I'll go now then... See you later... (*He goes.*)

ROSE: Bloody kids!

MARY: He's made a good job of it.

ROSE: Who? What?

MARY: The boy... The housework...

ROSE: It's alright.

MARY: He was too fast, don't you think...?

ROSE: Do what Mare?

MARY: He called them numbers out too fast... I was frightened to light a fag in case I missed a number...

ROSE: I don't miss numbers. They could drop a bomb and I wouldn't miss a number...

MARY: Well we're not all blessed with your powers of concentration Rose. Still he weren't bad looking though...

ROSE: Who?

MARY: The Caller.

ROSE: Do me a favour. I've seen better faces on the dead.

MARY: He wasn't that bad, surely? Perhaps I was sitting too far away. My eyes are not very good since I sold my glasses, only used them for reading. Don't read much now, don't read at all really, can't see without my glasses... So your Andy's not been?

ROSE: Doesn't look like it.

MARY: You don't think anything could have happened do you?

ROSE: Andy can look after himself.

MARY: Missed him, have you?

ROSE: A little. Although I wouldn't tell him that...

MARY: Why?

ROSE: He'd think I was soft...

MARY: Ohh...

ROSE: They take liberties if you're soft. You have to be hard.

MARY: I know Rose. I'm soft. I used to be hard when I was younger. But I'm soft now.

ROSE: I'm hard enough for the both of us!

MARY: Yes, Rose, you probably are... (*She takes her vodka from her bag.*)

ROSE: What do you think you're doing?

MARY: Ooooh... I thought I'd have a wee drink...

ROSE: It's that what's made you soft. Soft in the head.

MARY: I know...

ROSE: It'll do you no good Mary!

MARY: Just the one. I thought I'd have just the one...

ROSE: That's what you said at the bingo.

MARY: That was such a long time ago...

ROSE: Little more than half an hour.

MARY: Just the one Rose...?

ROSE: Just the one mind. Go on get a glass...

MARY: Thanks Rose, thanks... (*She gets herself a glass.*)

ROSE: You've got to give it up... (*MARY pours herself a drink with as much speed and dignity as she can muster.*)

MARY: Yes... I know... I will...

ROSE: It's ruined your life... Ouch...

MARY: What's the matter?

ROSE: It's me leg Mare, it ain't half giving me some pain.

MARY: Can I get you anything?

ROSE: No... I'll stand on it... I'm goin' to lay down soon...

MARY: You sure you're alright love?

ROSE: Yes.

MARY: Perhaps it means we're in for a bit of luck...

ROSE: I wouldn't think so Mary, it's been paining me all day, didn't bring us any luck at the morning session did it?

MARY: No...

ROSE: We never win anything. I'm gonna give the bingo up...

MARY: How many times have I heard you say that...

ROSE: I mean it this time. My luck's out. I'm fed up with it. No wins. No money. Up to my ears in debt. What's the point?

MARY: Rose, you've got to have your bit of enjoyment and if Bingo's your only hope... play...

ROSE: I never win.

MARY: You've had wins, I've been with you...

ROSE: Not what you'd call big wins. I've never had that big one, the one that would put my head above water and give me some hope. Sometimes I feel like ending it all...

MARY: Not you Rose...?

ROSE: That's the way I feel...

MARY: If I hadn't heard from my own mouth...

ROSE: I get so depressed what with my leg and all. It's the worry Mare, in my mind, the worry, if it's not one thing that's gotta be paid, it's something else... It's the damp, the debts, the windows...

MARY: What's the matter with the windows...?

ROSE: The ground floor.

MARY: I thought you wanted the ground floor for your leg...?

ROSE: Yes but there's no wire mesh outside.

MARY: Wire-mesh?

ROSE: You live on the ground floor, you're a sitting duck for any thief that comes along. All they have to do is tap a hole in the window, undo the lock and they are in. My Andy told me and he should know. I write to the council every week but do they do anything? Do they bollocks. It's all getting too much.

...AY: There's your Andy and the party to look forward to...

ROSE: Don't Mare, you're making it worse. If anything, it's them boys they'll give me the final push.

MARY: Don't say that. I'm sure they love you...

ROSE: Doesn't really make much difference...

MARY: Take some black and greens. They'll make you feel better.

ROSE: They're in the kitchen... (*MARY goes off to the kitchen.*)

MARY: (*Heard. Off.*) Take a couple, I'll join you...

ROSE: Not that they do me much good. After all the years of taking them, I've grown immune to them.

MARY: (*Heard. Off.*) Ooooh er... You have so many...

ROSE: You can't mistake them Mary, they're black and green.

MARY: (*Coming back on with pills and water.*) Have a sip of water... there you are...

ROSE: Ta.

MARY: Two for me. (*She takes hers with a swig of vodka.*) Rose all them pills in the kitchen, you won't do anything silly?

ROSE: Not before bingo tonight.

MARY: You'll feel better soon.

ROSE: Some hope...

MARY: Talking of bingo... At the lunch time session, when you shouted out: "Shake your balls up mate" I nearly died. Were you talking about his balls or the bingo balls?

ROSE: (*Laughs.*) Both Mare, both...

MARY: See I told you'd feel better. I knew it. 'Cause I feel better already and there was nothing wrong with me in the first place. I like to have a good stock of pills about me...

ROSE: D'you need some Black and Greens?

MARY: I could do with a few. My doctor won't give them to me. Say's they're addictive...

ROSE: What do doctors know? (*She throws the bottle to MARY.*) Take them home with you.

MARY: You sure you've got enough?

ROSE: I've got plenty and I can always get Trevor to run up doctors to get me some more.

MARY: I'll pay of course...

ROSE: Don't be silly.

MARY: No. I insist...

ROSE: It doesn't matter.

MARY: How much do you want?

ROSE: I don't know. How much can you afford?

MARY: Say two shillings a tablet...

ROSE: There were fifteen tablets in the bottle...

MARY: That's er...

ROSE: One pound fifty... D'you wanna count them...

MARY: Don't be silly. I trust you. (*Offers money to ROSE.*)

ROSE: Are you sure?

MARY: Go take it. I'd only pay more elsewhere...

ROSE needs no more encouragement she takes the money.

ROSE: I've got some sleeping tablets if you need them?

MARY: I've got these... (*Takes pills out of her bag.*)

ROSE: Let me see. (*Examining pills.*) These are no bloody good!

MARY: No?

ROSE: 'Course not. How many do you take?

MARY: Two or three a night...

ROSE: What did I tell you? Rubbish! My doctor tried to palm these off on me. I told him straight: "I don't want this shit." The ones he gives me now are so strong, I guarantee you, once your head touches that pillow, you are asleep.

MARY: Really...?

ROSE: Don't take my word for it. Try a couple. Take one before you go to bed in the morning, one mind – take two and you won't wake up the next morning. Here you are...

MARY: I couldn't...

ROSE: 'Course you can...

MARY: You're too kind...

ROSE: If you like them, I'll sell you some more next time.

MARY: My doctor's no good, won't give me anything except advice on what to eat and drink...

ROSE: Pakistani?

MARY: Yeah...

ROSE: You've definitely got to change him. They won't give you anything. Frightened of being called up in front of the Medical Council. Them being foreigners, they won't take chances.

MARY: All the good Doctors are dead...

ROSE: Mine's not, gives me anything I want...

MARY: Rose... Wasn't there something about him in the papers a while back?

ROSE: Lies. All lies. I won't hear a word said against the man. Been with him ever since I came to London. He's a bloody good Doctor. I'd trust him with my life. I'll have a word with him, get you on his books. Then you won't be short of anything.

MARY: Thanks love...

The sitting room door slowly opens.

TREVOR: Hello ladies...

ROSE: Ahhh... Oh shit. You bastard!

TREVOR: Nice welcome for your first born, who's just run to the post office and back for you.

ROSE: How'd you get in?

TREVOR: The door was open...

ROSE: Anybody could have walked in...

TREVOR: I left it open for Andy...

ROSE: He can knock like anybody else...

TREVOR: I've been standing outside that door listening to you two. The Dealer and her Junky.

ROSE: Nothing of the sort. Where's my money?

TREVOR: (*He hands over money and benefit book.*) I wasn't going to leave the country...

ROSE: Wouldn't put it past you...

TREVOR: Here's the twenty fags I promised you...

ROSE: You better not have bought them out of my money...

TREVOR: Check it. And don't say I never give you anything...

ROSE: About time.

TREVOR: And twenty for Aunty Mary...

MARY: That's nice of you dear...

TREVOR: Why do I call her Aunty, she's not your sister...?

ROSE: She's a very good friend...

MARY: You don't have to call me Aunty if you don't want...

ROSE: He'll call you what I tell him!

MARY: Well Rose, I really must be on my way. I'll see you outside the bingo tonight.

TREVOR: You're going to bingo again?

MARY: Gotta try your luck...

ROSE: Don't forget your sleeping tablets... In the kitchen...

MARY: Thanks love bye... (*She leaves.*)

TREVOR: So, you've added drug dealing to your CV?

ROSE: Don't be so bloody daft. I just lent Mary a couple of tablets. (*She lays on the sofa.*)

TREVOR: You going to sleep...

ROSE: No I thought I'd go on a long distance run.

TREVOR: You going bingo again tonight?

ROSE: Yes.

TREVOR: But Andy should be here. You don't wanna miss him.

ROSE: He'll still be here when I get back.

TREVOR: Not the same is it?

ROSE: I'm not rearranging the whole of my life to suit him.

TREVOR: Nobody's asking you to. You could give it a miss, just for one night.

ROSE: Not a chance. Now shud up I wanna sleep.

TREVOR: Where you getting the money?

ROSE: Mary's paying...

TREVOR: She gets on my bleedin' nerves...

ROSE: I've warned you about your swearing. Mary's alright...

TREVOR: Oh 'course she is, till she stops lending you money. It's the same with all your friends...

ROSE: I always pay back...

TREVOR: As soon as you do, you ask again.

ROSE: That's my business.

TREVOR: Oh come on Mum. Just for Andy. It would be nice. You might be overcome with a swell of Motherly affection and you want to give up all that for one night at bingo? You listening to me Mum... Mum are you asleep?

ROSE: How can I be with you babbling on...

TREVOR: D'you want me to tickle your feet?

ROSE: If you want.

TREVOR: Time was when you'd pay me sixpence to tickle your feet; when I was kid remember, a shilling if I picked the dead skin off your heel...

ROSE: Mmmmmmm.

TREVOR: How much you payin' today?

ROSE: Get off...

TREVOR: Lot more than a tenner, what with inflation an' all.

ROSE: In Cornwall when I was little, my father would go for his afternoon nap, sitting at the kitchen table, with his head in his arms. Forty winks he'd say. It was my job to look for fleas as he slept. A penny a flea I was promised...

TREVOR: Did you ever find any?

ROSE: No, he was having me on. I used to search for hours. Threw my heart and soul into that search for fleas...

TREVOR: In one of his letters Andy said he might move to Cornwall to get away from the East End...

ROSE: It's a pity your Grandfather is dead. He would have sorted Andy out. He used to wear his belt, with the buckle at the back. When you were about to get hit, he'd slowly turn the buckle around. 'Ere... You, you're supposed to be tickling not scratching.

TREVOR: Sorry. Out of practise... That better...?

ROSE: Hmmm...

TREVOR: Yeah I wanna take little Trev down there, show him his Cornish roots... Mum...? Mum...? (*No answer from ROSE. TREVOR gets up and takes one of her fags from the packet on the table.*)

ROSE: Put it back.

TREVOR: I thought you was asleep...

ROSE: Well I'm not.

TREVOR: Just this one I forgot to buy some for meself...

ROSE: I don't know what you do with your money...

TREVOR: I do have a woman and child to support...

ROSE: I warned you didn't I, you can't say you weren't warned.

TREVOR: It would have been the same with any girl...

ROSE: After all I went through with your Father, I expected you to have more sense. Black girls are free and easy...

TREVOR: That's what English men say about white women that go with black men Mum, what does that make you...

ROSE: You ask your Dad, he'll tell you...

TREVOR: Dad's glad I'm with a black woman. He's proud of me. The only sensible thing to do in this country, he says...

ROSE: Your Father's a two-faced liar. He's never been with a black woman in his life. Now shud up. I wanna sleep...

TREVOR: Dad's waiting for the right one to come along...

ROSE: Right what?

TREVOR: Black woman.

ROSE: Your Father's full of shit!

TREVOR: You jealous?

ROSE: Me jealous of your Father. That'd be the day.

TREVOR: Light still burning eh?

ROSE: That light went out years ago.

TREVOR: I bet if he did get together with a black woman, that'd really crease you, wouldn't it?

ROSE: I couldn't care less about your Father.

TREVOR: You would've lost your hold...

ROSE: I've got no hold over your Father...

TREVOR: How come he's never married again?

ROSE: I don't know. We was never married in the first place.

TREVOR: Oh I see I'm a bastard now...

ROSE: For want of a better word.

TREVOR: You really know how to make me feel secure...

ROSE: It didn't worry me...

TREVOR: Doesn't worry me but it's nice to know these things...

ROSE: Nobody cares these days...

TREVOR: I've just had a thought... I must be what they call these days a love child...

ROSE: There was no love...

TREVOR: It's all become clear to me now, the root of all my problems, parents who never married or loved each other.

ROSE: Here... I've just figured you out. You've invited your Father haven't you?

TREVOR: Pardon?

ROSE: You bloody heard you've invited your Father to come round here. You daring little sod! I don't want him round here. I don't want to see his ugly mug. If he comes round here I'll push him over the balcony...

TREVOR: You haven't got a balcony any more Mum, you live on the ground floor...

ROSE: Don't you tell me where I live, you scheming swine, let go, let go of my leg... You can go and tell him, I don't want his black, African backside in my house...

TREVOR: (*Still holding onto her leg.*) Sssshhh Mum...

ROSE: Don't you ssshh Mum me. You think he's an Angel, he was no angel, left all the aggravation to me... Go and have the party... reunion in his poxy bedsit...

TREVOR: Calm down Mum. (*Still tickling her feet.*) I wouldn't invite him here, knowing how you feel. Please Mum give me some credit. I'm not that stupid...

ROSE: You better not...

TREVOR: I haven't. My life...

ROSE: Got enough on my plate without seeing that bloody old African, don't want him driving me mad. (*Laying back on sofa.*)

TREVOR: I know you don't... You wanna sleep... you've had a long day, legs been achin', try and get some sleep before you go to bingo tonight...

Lights fade to black out.

It is dark except for the orange glow from the street lamps outside. Most of the furniture has been pushed neatly to the edges of the room. The table and four chairs have been set rather formally. On the table a bottle of bacardi, coca-cola, four classes and a bag of crisps. On the radiogram, the original version of "Some guys have all the luck". TREVOR lays asleep on the sofa facing the audience. The sitting room door opens. A figure enters, walks cooly around, notices TREVOR on the sofa. He switches light on.

TREVOR: (*Wakes with a start.*) Hmmm... eh... what? Andy!!! It's you... What time is it? Where have you been? How are you?

ANDY: Which question d'you want me to answer first?

TREVOR: Sorry... Just woke up...

ANDY: I'd've never guessed.

TREVOR: It's really great to see yer... How you doin'?

ANDY: Can't complain. Yourself?

TREVOR: Knackered. Mum's had me runnin' about all day... (*Stands a little groggy on his feet.*) What happened to your hair? Where's your Afro man?

ANDY: Cut it off.

TREVOR: Why?

ANDY: Fed up with it. Didn't expect to find you here.

TREVOR: Waiting for you.

ANDY: How long?

TREVOR: All day. You usually come and see Mum first, what happened?

ANDY: Change of plans.

TREVOR: You alright?

ANDY: 'Course.

TREVOR: You ain't in trouble with the old bill already?

ANDY: Don't be silly. Sorry about using your name.

TREVOR: That's alright. Although it was a bit of shock to come home and be told I'd been nicked for burglary...

ANDY: Had to do it. I was up on other charges and yours was the first name that popped into my head.

TREVOR: Glad to be of some help...

ANDY: Marcia wasn't too keen on the idea...

TREVOR: She was all for it...

ANDY: She wasn't.

TREVOR: She was...

ANDY: Marcia wrote to me while I was inside.

TREVOR: Oh...

ANDY: Telling me how unfair it was that I should give you a criminal record, when you had not done anything criminal.

TREVOR: It's none of her business. You're my brother.

ANDY: She's your woman. So where's the dog, I missed its bark as I climbed through the window...

TREVOR: She sold it. Needed the money for bingo. The way she tells it, she sold Sheba to pay her debts. For weeks after she tried to win the money to buy back the dog. Never happened, shame really, Mary and Sheba were the only company she had...

ANDY: Good job. She showed that dog more affection than she ever showed us. (*He moves around the flat.*) New settee?

TREVOR: She got it from the catalogue...

ANDY: Colour television?

TREVOR: Visionhire...

ANDY: Radiogram?

TREVOR: Rumbleows ...

ANDY: Carpet?

TREVOR: Blundells...

ANDY: There's nothing in this flat that isn't on H.P.

TREVOR: An' she's behind on all of them. She wants them to take her to court, gives 'em a sob story and ends up paying, five shillings a week...

ANDY: You'd've thought they'd have caught up with her by now.

TREVOR: She uses so many false names, she sometimes forgets who she is, when she opens the door.

ANDY: (*Pointing to set table.*) What's all this?

TREVOR: For you.

ANDY: For who?

TREVOR: You.

ANDY: Me? Mum bought all this for me?

TREVOR: I did.

ANDY: What?

TREVOR: Bought the stuff, it was my idea...

ANDY: Idea, what idea?

TREVOR: A party...

ANDY: This is a party?

TREVOR: To celebrate your release and freedom.

ANDY: I see a party.

TREVOR: More a family reunion...

ANDY: I take it the Nigerian and Cornish branches of the family haven't been invited?

TREVOR: Not all of them...

ANDY: (*He points to each chair and...*) You, Mum, me. (... *chair four.*) You've invited Dad here?

TREVOR: Mum'll think the fourth chair's for Aunty Mary...

ANDY: She's not our Aunty! Who invited her?

TREVOR: Don't look at me that's all down to mum. We'll soon get rid of Mary...

ANDY: Will we?

TREVOR: Well, what do you think?

ANDY: About what?

TREVOR: The party?

ANDY: I was wondering who'd hit you over the head with a cricket bat. Inviting Dad here.

TREVOR: I thought it'd be nice...

ANDY: Nice? For who?

TREVOR: You, Mum, me, all of us, the family together in the same room. I thought...

ANDY: You thought! What is your problem? Mum and Dad hate each other.

TREVOR: No they don'...

ANDY: Yes, they do.

TREVOR: Not really...

ANDY: Not really? The last thing I heard them say to each other was: 'Get back to Africa you black bastard' and 'May you burn in hell, you pink-face cow.'

TREVOR: Sticks and Stones...

ANDY: Mum and Dad don't fight with sticks and stones, they fight with guns and bombs. Black against White. Women against men. It's total...

TREVOR: I thought you coming out might make it different...

ANDY: Some optimist you are. It certainly will be a family reunion with a difference. A white woman, who don't like black people, a black man who doesn't like white people, a hopeless dreamer, an ex-convict and to top it all a diabetic, scottish alcoholic...

TREVOR: (*Laughs.*) Well I tried...

ANDY: Who drinks Bacardi?

TREVOR: Rod Stewart...

ANDY: Is he coming?

TREVOR: What's good enough for Rod Stewart is good enough for my brother...

ANDY: Let's have a drink...

TREVOR: Shouldn't we wait for the rest of the family...

ANDY: What family...? You and me are family enough.

TREVOR: Yeah... right... (*ANDY pours each of them a drink.*) Wait! One minute... (*TREVOR takes ice and lemon from the ice bucket.*) Can't drink Bacardi and coke without ice and lemon. It's not the done thing.

ANDY: (*Holding up his glass.*) To my brother!

TREVOR: Likewise! (*They clink glasses.*)

ANDY: Cheers!

TREVOR: Cheers! (*Pause.*) Where are you stayin'?

ANDY: With Kale.

TREVOR: She's a nice girl...

ANDY: She's a nice looking girl. Although I'm fed up with her.

TREVOR: Give her a chance, you've just got out...

ANDY: She's convenient that's all. I've got no real feelings for the girl. I'm a different person from the one she met... So what's happening?

TREVOR: Nothing much. I'm out of work. Marcia's pregnant.

ANDY: Again?

TREVOR: It'll only be our second...

ANDY: Little Trev's not even two...?

TREVOR: Eighteen months...

ANDY: Haven't you two heard of contraceptives?

TREVOR: 'Course...

ANDY: Do you use them though?

TREVOR: Marcia's goin' on the pill after this one.

ANDY: Good and what about you?

TREVOR: I don't take the pill...

ANDY: Very funny. Have you ever used a durex...

TREVOR: Na, don't be silly I can't be bothered with all that.

ANDY: You don't know how to use one...

TREVOR: 'Course I do...

ANDY: Go on then tell me how...

TREVOR: That's not the point, this child was wanted, it was no accident.

ANDY: Yeah sure. So you got a family. You'll need a job...

TREVOR: So everyone keeps tellin' me. But packin' boxes, humpin' crates, sweatshops, that's all that's out there for me. I was educated for more, better. You remember Miss Scott, our foster mother, in Lowestoft, she had me playing the violin and speaking French at the age of nine, remember that little primary school in the village.

ANDY: Trouble is there's not much call for French-speaking violinists in the East End...

TREVOR: Lowestoft was the best home we was ever in.

ANDY: Miss Scott's plans for me were a lot less ambitious. She just wanted to stop me being an eight-year-old thief. She tried so hard. Not once did she ever shout at me, or hit me. I really liked that woman...

TREVOR: D'you remember Hastings?

ANDY: Geoffrey and Steven. They had everything we never had...

TREVOR: And desperately wanted?

ANDY: Fair hair.

TREVOR: Blue eyes.

ANDY: White skin.

TREVOR: A strong but fair Father.

ANDY: A wonderful caring Mother.

TREVOR: Big house. Big garden.

ANDY: With trees. A treehouse.

TREVOR: Our own beds...

ANDY: And bedrooms.

TREVOR: Satchels with our initials. G and S.

ANDY: Geoffrey and Steven.

TREVOR: You be Geoffrey, I'll be Steven...

ANDY: No. You're always Geoffrey. I want to be Geoffrey
 and you be Steven.

TREVOR: And run like this...

*They both ape Geoffrey and Steven running. High knee and arm
action. They stop out of breath and laughing.*

TREVOR: I used to hate being black, my curly hair,
 every night I'd tug at it, pull it, comb it, wet it, plaster
 it with brylcream. In a desperate but futile attempt to
 straighten it.

ANDY: There wasn't many of our sort in Lowestoft.

TREVOR: How I wished I was white in those days...

ANDY: We had no role models...

TREVOR: Now I wouldn't exchange my Afro for all the tea
 in China. I'm glad I know what I am now.

ANDY: And what's that?

TREVOR: Black of course...

ANDY: Why of course?

TREVOR: Because that's what we are...

ANDY: We?

TREVOR: If you're not white you're black...

ANDY: What kind of perverse logic is that. So you classify the Chinese do you?

TREVOR: You know what I mean. So you sayin' you're not black?

ANDY: That's right, I'm a sort of golden brown.

TREVOR: I'm proud to call myself black.

ANDY: 'Spose that's why you're living with a black woman...

TREVOR: That's right. I see what happened with Mum and Dad. I didn't want my wife calling me a black bastard when we're not getting along...

ANDY: You normally marry someone because you love them, not because they're not going to call you a black bastard.

TREVOR: I do love her.

ANDY: That's alright then.

TREVOR: You used to be all for it; Black Power, the haircut, the salute...

ANDY: I've just decided that I am a human being, who's going to get on in this world and I owe no allegiance to anyone, thing or race...

TREVOR: Do you ever wonder how we might've turned out if we'd stayed with Miss Scott in Lowestoft?

ANDY: No. That was the past. It means nothing. You've gotta start dealing with now. You failed your eleven plus, you left school without a qualification to your name. You've got a son, another kid on the way, you need money, you don't get money by dreaming. Grab

whatever job's going. Go to night school. You've got to make an effort.

TREVOR: 'old it, hold it. We've got all this arse-backwards. I'm the oldest brother. I'm the one who should be giving advice... I used to look after you. I was your bodyguard from the age of four up until you were thirteen. I never let anyone take liberties while we were in the homes...

There is a knock at the door. TREVOR stands frozen.

TREVOR: It's probably Dad...

ANDY: Aren't you going to open the door?

TREVOR: Yeah, sure... (*He goes to the door.*)

ANDY: If it's the old bill, let me know. I'll be in the bedroom...

TREVOR: The old bill? What...? Why...? Oh shit...

ANDY: Don't panic, just answer the door...

ANDY goes off to the bedroom. TREVOR takes a deep breath and slowly goes off to answer the front door. After a pause. Heard.

TREVOR: (*Heard. Off.*) Where's Mum?

MARY: (*Heard. Off.*) She's at the bingo...

TREVOR and an out of breath MARY enter, she looks around.

TREVOR: What are you doin' here Mary?

MARY: Your Mum sent me from the bingo...

TREVOR: My mum sent you?

MARY: (*Still catching her breath.*) Oh I don't mind... I'd do anything for your Mother... It was her leg you see, I didn't want her exposing it to the cold... I said I could get here and back to the bingo quicker than she could... she didn't want to miss the late session...

TREVOR: What did she send you to do?

MARY: Check... Check up...

TREVOR: On what?

MARY: On you... the flat... just make sure everything's alright and that your Father isn't here...

TREVOR: Dad's not coming here...

MARY: Is he not?

TREVOR: No.

MARY: Your Mother thought...

TREVOR: Well she's wrong. (*Much to TREVOR's dismay MARY sits, she's eyeing the Bacardi.*)

MARY: Your Mum'll be pleased. It's all very exciting isn't it. What with... and the party. Of course, I'll just have the one drink, then I'll make myself scarce. You don't mind if I come in these clothes. I haven't got time to change. I'm so looking forward to it. It's such a long time since I've been to a party.

TREVOR: Well you're welcome...

MARY: I hope you won't think me forward, but would you mind if I poured myself a quick one, to warm myself up before I trek back to the bingo...

TREVOR: Go ahead... (*MARY quickly pours herself a drink.*)

MARY: Ta. I know I shouldn't but I just can't help it. It steadies the nerves and the walk...

TREVOR: (*Pouring himself a drink.*) Why didn't you go back to your home, your family?

MARY: No. Couldn't do that...

TREVOR: But why there's nothin' down here for you...

MARY: It's the shame...

TREVOR: That's the same thing my Dad says about Africa, what sort of families do you come from that can't forgive a few mistakes?

MARY: It's not them. It's us that feel the shame. Because we were the big shots that knew better than all the family and friends we left behind. We were going to conquer the big city. Look at us now...? How can we go back...? ... Well I can't stand about chatting all day. I've got to get back to the bingo. Your Mother will be worrying, and she's got enough to worry about...

TREVOR: Yeah, right.

MARY: Oh I nearly forgot? Mum wants to know if Andy's been?

TREVOR: Err... no...

MARY: If and when he has, she says for him to wait.

TREVOR: Right.

MARY: Bye.

TREVOR walks MARY off to the front door. ANDY comes out the bedroom and flicking on and off the lighter ROSE was using earlier. TREVOR comes back on.

TREVOR: I feel really sorry for her...

ANDY: Yeah, she had it all. Money in the bank, jewellery, houses all over the East End. For some it's drugs, for some it's gambling. It's alcohol that put an end to Mary's glittering career...

TREVOR: What did she do?

ANDY: Mary? Mary was the Whore with a heart of gold...

TREVOR: (*Splutters.*) Prostitute!!! Mary?

ANDY: You're so naive. Where d'you think she got the houses, the jewellery?

TREVOR: But she's diabetic...

ANDY: Yeah a diabetic prostitute. According to Mum, she was very beautiful. Mum's known Mary since she came up to London. Mary showed her the ropes. They use to hang round together when Dad first went to prison.

TREVOR: Mum never told me...

ANDY: Mum only tells you what she wants you to know... I sometimes wish Mum had done what Mary did...

TREVOR: What been a... a... a?

ANDY: A prostitute. Instead of puttin' us in homes.

TREVOR: You're joking?

ANDY: I'm not. I would have been really proud of her. It would have been a heroic gesture don't you think, to make that sort of sacrifice for her children?

TREVOR: No I do not. It wouldn't have been right...

ANDY: You're too sentimental. At least it would have shown she cared about us...

TREVOR: She does in her own way...

ANDY: Don't talk bollocks. Not once did she come to visit me while I was inside...

TREVOR: It was her leg. It's been pretty bad...

ANDY: Why doesn't she have the bleeding thing amputated then?

TREVOR: It has been painful...

ANDY: Feel her pain do you?

TREVOR: No... she told me... She acts as though she's in pain...

ANDY: Acts is the right word. She is the world's greatest actress. She didn't visit me because she didn't care. Why are you making excuses for her...

TREVOR: She is our Mother...

ANDY: When's she ever been a Mother to us. We were in children's homes from the time we were three up until we were old enough to go to work. You think all that was by chance. It was cold, calculating...

TREVOR: She had it hard after Dad left, on her own in London with two black kids...

ANDY: She didn't try, she never took an interest, never asked me how I was doing at school or what my plans were, all she was ever interested in was how much moncy I had...

TREVOR: D'you want another drink?

ANDY: No thanks and I think you've had enough...

TREVOR: It's supposed to be a party... few drinks go over old times... I want us all to be a family...

ANDY: Trev, life's not like the films or records you listen to, it don't all come right in the end. Mum, Dad, you, me, we never existed as a family. Forget it. You've got your own family now, look after them.

TREVOR: Mum needs us now...

ANDY: Too bad. I don't need her.

TREVOR: Why d'you come round...?

ANDY: To pick up my lighter? (*He shows TREVOR the lighter.*)

TREVOR: She treasured that lighter...

ANDY: Too bad.

TREVOR: She hardly ever used it... She'll be upset...

ANDY: She's no right to be. I stole it in the first place. It's worth a lot of money... Nearly three grand...

TREVOR: Do what?

ANDY: Come out of a posh hotel up West. Solid gold, the little glass beads as Mum calls them, are diamonds...

TREVOR: Mum didn't have the faintest idea.

ANDY: That was the plan. If she did it would have been straight down the pawn shop...

TREVOR: She's been sleeping on three grand, she'll do her nut!

ANDY: I was going to pay off her debts when I was first inside but then I thought what's she ever done for me? Na, this is my nest egg. I'm not going back inside, I'm going strictly legit. I've got plans...

TREVOR: Like?

ANDY: America. Like as far away from the East End as possible. The positive aspect of being mixed race and brought up in so many different children's homes, is that I know I can fit in anywhere...

TREVOR: What about me?

ANDY: I'll write... we'll talk on the phone, we'll have our own, proper family reunions...

TREVOR: Yeah... (*Pause.*) So you're not staying for this party?

ANDY: No. Sorry...

TREVOR: Na, it's alright...

ANDY: You got money?

TREVOR: A bit...

ANDY: (*Taking out a wad of fivers. Hands five to TREVOR.*) For my Nephew...

TREVOR: Andy you haven't, not already...

ANDY: Relax brother, it's an advance on the lighter.

They laugh. A pause.

TREVOR: Well...

ANDY: I'll visit you and the baby before I go...

TREVOR: Good... You take care...

ANDY: And you...

They shake hands. Then hug.

ANDY: I'm proud that you're a father.

TREVOR: Thanks.

ANDY goes. TREVOR, crestfallen, plays radiogram "Hickory Hollers Tramp". He sits at the table, takes a cigarette butt from the ashtray, lights it. Pours himself a very large Bacardi and coke. Downs it in one. Shivers. Pours another one. He is about to drink, when there is a knock at the door.

TREVOR: Dad...?

TREVOR downs the drink, places the glass on the table, blows out the candles and goes off.

Blackout.

Darkness. The light is switched on. ROSE and MARY enter in coats with handbags. ROSE is tired, she yawns as she takes her coat off. MARY on the other hand is bubbling with excitement.

MARY: Trevor must've gone for cigarettes.

ROSE: Good. We'll have some peace. (*She shouts.*) Trevor!

ROSE limps over to her bedroom door opens it, looks in satisfied no-one is there. She goes straight to MARY.

ROSE: Now listen Mary. Not a word.

MARY: You can trust me Rose...

ROSE at the living room door, a quick peep into the passage.

ROSE: Trevor!

She waits. No reply. She firmly shuts sitting room door.

ROSE: Not a word to anyone. Understand?

MARY: Not a dicky bird Rose...

ROSE: No-one. No-one at all!

MARY: Right...

ROSE: You got that Mary?

MARY: Yes Rose.

ROSE: Not even the kids. Mary, why are you winking?

MARY: I'm keeping mum... (*She giggles.*)

ROSE: What's the bloody matter with you Mary?

MARY: Nothing Rose. It's the excitement of it all...

ROSE: You haven't been at the whisky? You know you go all silly when you drink whisky...

MARY: I haven't I swear. It's just now you'll be able to pay off some of your debts...

ROSE: Don't be daft...

MARY: But you won Rose, you won!

ROSE: Shut up Mary. I've told you I don't want anyone to know. Least of all my Trevor or I'll have him round here bumming all the time...

MARY: You'll treat him though...?

ROSE: I'll treat him to the back of my hand.

MARY: Rose!

ROSE: I'll buy the baby something...

MARY: It's nice to have money, so you can afford little treats like that.

ROSE: I thought you said you could keep your mouth shut!

MARY: I'm sorry Rose.

ROSE: It's best kept quiet. We don't want the social finding out, do we...?

MARY: No... no we don't... (*Whispering.*) Your luck has changed in a big way...

ROSE: Don't make me laugh. Two hundred pounds. Where does that go these days? All I can say with any certainty, is that I'll be going to bingo tomorrow...

MARY: Not only that your son's free...

ROSE: Yeah and now the worry starts.. .Where's he been... he's not here... He hasn't been all day. I'll bet he's in some kind of trouble...

MARY: No Rose, he'll be here...

The sitting room door opens, a pale looking TREVOR ambles in.

ROSE: Where the bloody hell have you been?

TREVOR: In the toilet.

ROSE: What the hell were you doing in there?

TREVOR: Being sick. Vomiting...

ROSE: You been listening?

TREVOR: To what?

ROSE: Nothing.

TREVOR: You have any luck?

ROSE: No. (*Nudges MARY.*)

MARY: No.

ROSE: Has he been?

TREVOR: Who would that be?

ROSE: You know who I'm talking about...

MARY: Andy?

TREVOR: Oh him, he's been and gone.

ROSE: What do you mean been and gone?

TREVOR: He was here. He went. Simple enough for yer?

ROSE: He wouldn't have gone without seeing me...

MARY: Of course he wouldn't...

TREVOR: He did.

ROSE: He should've waited...

TREVOR: What for?

ROSE: I'm his Mother.

TREVOR: Oh yeah I was forgetting.

ROSE: I haven't seen him in over a year...

TREVOR: Is that his fault...

ROSE: I was only at the bingo...

MARY: Just down the road...

ROSE: You should have told him to wait...

TREVOR: If you wanted to see him so badly why didn't you stay in?

ROSE: I've been in all day.

TREVOR: You've been to bingo morning, noon and night...

ROSE: So?

TREVOR: So, you haven't been in all day.

ROSE: I don't live my life to suit you...

TREVOR: That's been pretty obvious from the day I was born.

ROSE: If you wasn't here, Andy would have stayed!

TREVOR: Oh I see, it's my fault now, is it. Couldn't have nothing to do with you could it?

ROSE: He'll be back...

TREVOR: I don't think so...

MARY: 'Course he will, he loves his Mother...

TREVOR: But did she ever love us?

MARY: What a question?

ROSE: 'Course I do, I'm your Mother.

TREVOR: I've never felt it. Not deep down... (*He goes to the table pours a large drink gulps it down in one.*)

MARY: I think I'd better be going.

ROSE: You stay Mare!

TREVOR: I wanted to feel your love mum, but if I'm honest I never have...

ROSE: You soppy sod. How d'you want me to love you? With kisses, cuddles and pats on the bum. You're not a child anymore.

TREVOR: You never had us when we were children...

ROSE: That's not my fault. I've told you before. I tried...

TREVOR: How hard did you try Mum?

MARY: She did make a home for you.

TREVOR: We were in children's homes for over twelve years. What sort of home takes that long to make. A twenty-four bedroom mansion in the country? This is a poxy two bedroomed flat in the East End of London. How hard did she try?

MARY: It has got central heating...

ROSE: I did my best.

TREVOR: Tell me how hard it was, with your two children locked away in some state-sponsored children's home, and you happily danced around the East End with every black man you laid eyes on...

MARY: It wasn't all fun... She missed you... Your Mother talked about you all the time...

TREVOR: Talk is cheap isn't that what you are always telling me, Mother dear?

ROSE: I'm not telling you anything...

TREVOR: Then Aunty Mary will, won't you Aunty Mary?

MARY: I don't want to get involved...

TREVOR: Oh but you are involved...

MARY: Oooh no... Is that the time...? I've got to go...

ROSE: Mary...

MARY: No Rose, I'm sorry, I must go. I'm sorry. I'll see you at the bingo tomorrow...

MARY hurrys out. ROSE and TREVOR are left looking at each other. TREVOR slumps on the sofa.

ROSE: Haven't you got a home to go to?

TREVOR: I thought this was my home. The family home...

ROSE: This is my home and you've got no right, showing me up in front of my friends like that...

TREVOR: I don't care...

ROSE: Well I bloody do... Listen... I'm tired... I'm going to bed... you go home and do the same...

TREVOR: I'm not tired.

ROSE: Go home and wake your wife then. I've got to be up early in the morning...

TREVOR: Bingo that's all you've got to get up for. You're a bingo junky, that's what you are.

ROSE: That's it. I've had enough. I'm sick and tired of the sound of your voice. Just get out!... Did you hear what I said?

TREVOR: (*Standing up.*) I'm not going anywhere...

ROSE: Don't you stand up to me my lad...

TREVOR: How are you going to get me out Mum, I'm too big for you to frighten off with a belt or a broomstick...

ROSE: I'll call the police...

TREVOR: You can always rely on them, can't you Mum?

ROSE: I want some peace. Why don't you go home?

TREVOR: Why were we in children's homes all those years?

ROSE: Ask your Father.

TREVOR: I did this evening, while you were at bingo...

ROSE: Your Father came here?

TREVOR: Don't worry, he didn't come in. He wouldn't. Andy had already gone and he didn't want to see you...

ROSE: I don't want to see him...

TREVOR: Feeling's mutual. Anyway he said, he'd've been happy to take us out of the homes. But you wouldn't let him.

ROSE: He'd been to prison... You's was my kids...

TREVOR sits in an armchair, his head in his hand and starts to cry. Which disconcerts ROSE.

ROSE: Oi...!

TREVOR: Eh?

ROSE: What's the matter with you?

TREVOR: Andy's been and gone Mum...

ROSE: I know... you said...

TREVOR: What's it all about Mum, what's the story? 'Cause don't know... I'm not sure I... What is this shit, you don't know... I expected so much from this day...

ROSE: It'll be alright...

TREVOR: Will it? How?

ROSE: It just will...

TREVOR: What's it all about Mum?

MUM: What? What's the matter with you?

TREVOR: I'm confused Mum... A loser... That's me...

ROSE: Son?

TREVOR: Since when have you ever been a Mother to me? I wanted you to be... but you didn't try very hard, did you?

ROSE: It wasn't my fault...

TREVOR: Why do I get this feeling that you never bloody cared...?

ROSE: Don't you swear at me!

TREVOR: Why?

ROSE: I don't have to explain myself to you!

TREVOR: Don't yer!

ROSE: What do you know? You know nothin'! You with your council flats and social security. You try living in one room. You try getting money out of the U.A.B. And all the while they're lookin' down their noses at you because you've got a couple of darkie children... All that African talk and nonsense. He had some African woman I'd never seen before come in and look at your feet on the day you was born. I wasn't allowed to say a word. All that might be alright in Africa but I ain't no African woman! Care... I cared... I bleedin' cared. Nappies boiling in a bucket on the stove. Andy crying his head off. The electric went. And I didn't have poxy shilling for the meter. Couldn't heat the place. Drained the nappies damp as they were, put 'em in a bag. You two in a pram and... and I couldn't cope... I couldn't cope......

TREVOR: I'm sorry Mum...

ROSE: You're sorry. I'm sorry I ever met your Father.
I learnt my lesson there and then. Never again would
I rely on anything from dirty black, bastard, men.

TREVOR: (*Pause.*) I'm a black bastard Mum...

ROSE: No you're not you're half white.

TREVOR: I'm black.

ROSE: I'm your Mother and I'm tellin' you, you're not.

TREVOR: I know what I am. I'm a proud black man. D'you
understand? It's gone on long enough. Just because you
had a difficult time with Dad, don't give you the right
to insult black people. I've got a wife and son who are
black, I don't want them to hear that racist bullshit,
least of all from my Mother.

ROSE: I beg your pardon?

TREVOR: You heard.

TREVOR makes for the door.

ROSE: Where do you think you're going?

TREVOR: Home.

ROSE: I'm no racist... I haven't finished with you yet...

TREVOR: Oh yes you have. Bye Mum.

He goes off, closing the door behind him.

ROSE: Go on then piss off. See if I care. None of you are
any good!

*In a fit of temper, she throws her handbag at the living room
door, it crashes against the door, opening. A bundle of money flies
out and scatters all over. ROSE quickly limps over to the money.
She bends to pick it up.*

ROSE: Ouuch! Poxy leg.

Lights fade to blackout.

The End.